A–Z
OF
SHREWSBURY

PLACES - PEOPLE - HISTORY

Dorothy Nicolle

AMBERLEY

First published 2022

Amberley Publishing
The Hill, Stroud, Gloucestershire, GL5 4EP
www.amberley-books.com

Copyright © Dorothy Nicolle, 2022

The right of Dorothy Nicolle to be identified as
the Author of this work has been asserted in
accordance with the Copyrights, Designs and
Patents Act 1988.

ISBN 978 1 4456 9587 7 (print)
ISBN 978 1 4456 9588 4 (ebook)

British Library Cataloguing in Publication Data.
A catalogue record for this book is available
from the British Library.

Typesetting by SJmagic DESIGN SERVICES,
India. Printed in Great Britain.

Contents

Introduction

I came to live in Shropshire some thirty years ago, and it only took me a few months to realise that I had truly landed on my feet. This county has everything you could wish for – beautiful countryside, markets and restaurants for even the most demanding of cooks and gourmets, lively events to entice a wide variety of interests, fascinating history (my own personal love) and the friendliest of people. Who could ask for more?

I haven't written a dedication for this book because it is really dedicated to all those wonderful people who have made living here such a pleasure. But it is especially dedicated to those of you who love the county town. Shrewsbury is a diamond among other jewels. No, not a diamond, diamonds can often be somewhat brash. Shrewsbury has the subtlety of, perhaps, an opal – a stone that seems quiet and undemanding but, depending on how you turn it in the light, can give off different colours and stun you with its beauty. Yes, that's Shrewsbury.

When I first began to list ideas for an A to Z of the town I came up with dozens of subjects. So much so that it would take an enormous volume to include them all. Consequently, I decided, like the opal, to try and be a bit more subtle and introduce (or remind) those of you who also love this town to rather more unusual subjects. For example, Charles Darwin obviously has to be included, but what about his father, Robert, who tends to be ignored? Then there's a pub in the town named after the famous Admiral Benbow, but what about his relative, Captain Benbow?

And so, hidden among the obvious I've included some rather more quirky aspects of a town that has to be one of the most fascinating in all of Britain. See what you think.

Abbey, Shrewsbury

There's a wonderful story about the founding of Shrewsbury Abbey. It tells how Roger de Montgomery (one of William the Conqueror's generals), having recently 'acquired' the county of Shropshire, decided to found an abbey in his new territory upon the recommendation of his clerk, the gloriously named Odelirius. Roger looked around the town and noticed a little wooden church sitting across the river, outside the town boundary, and decided it would do nicely. He walked into the church, laid his gloves on the altar and announced that this would be his abbey.

That all happened in 1083, and within a few years the abbey was established. Unusually for the time, it was totally independent, with no controlling church either in England or in France, as was then common. But such places need money to run them and, even without having to pay a tithe to a mother church, the monks here decided they had to augment their income somehow.

The best way to do that was normally to attract pilgrims to a local saint associated with the site, but this was a new abbey with no such connections. And so, the monks in Shrewsbury searched for a suitable saint whose remains could be brought to the town and attract pilgrims with cash in their pockets. And they found one.

The saint they chose was called Winifred, and the monks, deciding that she would be most suitable, travelled all the way to Snowdonia to retrieve her bones. But why did they choose St Winifred?

Winifred was a beautiful maiden who lived in northern Wales. One day, so the story goes, a young man, Prince Caradog, passed by the house where she lived and was so struck by her beauty that he attempted to force himself on her. Winifred fled to the nearby village, but Caradog chased after her and, as he caught up, drew his sword and sliced off her head. Fortunately for Winifred, the local priest, St Beuno, saw what had happened, lifted Winifred's head off the ground and replaced it on her shoulders. Instantly Winifred came back to life. The site where this miracle happened has been a site of pilgrimage ever since – it's Holywell in north Wales. As for Winifred, she retired to a convent in Snowdonia where she died in around AD 660.

The Shrewsbury monks subsequently built a shrine in her honour and, such was the attraction of St Winifred, by the time of the Dissolution of Monasteries in the

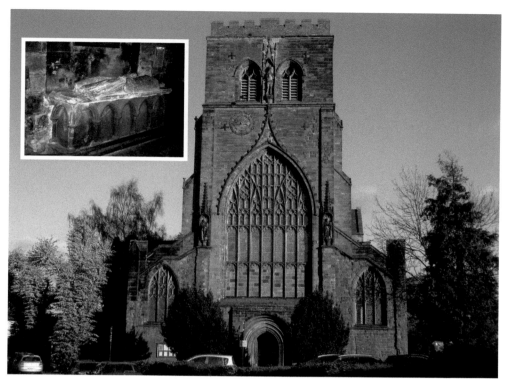

Above: Shrewsbury Abbey.

Inset: Roger de Montgomery's tomb in the abbey he founded.

1500s Shrewsbury Abbey had become very wealthy. But, inevitably, the abbey was dissolved and Winifred's shrine destroyed along with it so that, today, just a small section of carved stone survives.

Incidentally, that story about Odelirius comes to us from his son who had an equally wonderful name – Ordericus Vitalis. Vitalis was baptised (and presumably therefore born) in nearby Atcham. At the age of ten or eleven he entered a monastery in Normandy and grew up to become a historian. It's largely thanks to him that we know so much about William the Conqueror's reign, and it is perhaps because of his mixed Norman and English heritage and the fairness with which he looked at both sides of the conflicts of those years that he has since been described as being 'an honest and trustworthy guide to the history of his times'.

Aethaelflaeda, Lady of the Mercians

Aethelflaeda was the daughter of King Alfred the Great. At the age of twelve, as part of an alliance, she was married off to Aethelred, Earl of Mercia. At this time Alfred

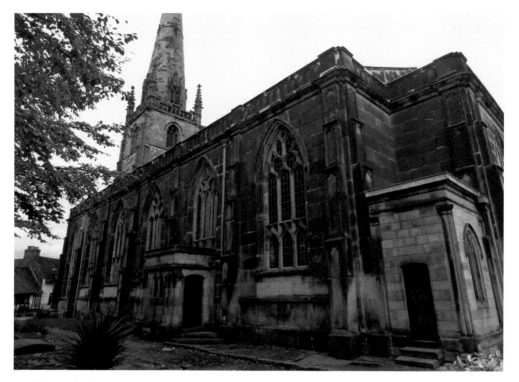

St Alkmund's Church.

was fighting against Viking incursions on the borders of his territory of Wessex and probably wanted to strengthen his control, through such an alliance, over those lands between Wessex in the south and the Danes to the north-east.

Interestingly, when her husband died Aethelflaeda ruled Mercia in her own right, and during this time she strengthened her borders by establishing a number of castles including those at Runcorn, Warwick and Hereford. It's possible that she also established an early Saxon castle at Shrewsbury, although there is no evidence whatsoever to prove this. However, she is understood to have founded a church, St Alkmund's, in the town sometime around AD 910.

Armoury, The

Many towns have buildings that have been physically moved at one time. Most such buildings are timber-framed ones that could be easily dismantled and then re-erected elsewhere and, certainly, Shrewsbury has one of these (it's Castle Gates House, in case you are interested).

The moving of brick buildings, however, is rather more involved but that is what happened with the Armoury, now a pub and restaurant near the Welsh Bridge but

once an armoury for the local militia and situated near the London Road. It was first built in 1806 by the architect James Wyatt, who is perhaps best known these days as the designer of the Broadway Tower in the Cotswolds. As an armoury, however, it was something of a white elephant, being both inconvenient and somewhat insecure as a place to store weaponry.

And so, it was sold – twice – finally ending up as the property of Lord Berwick of Attingham Park. Berwick had great plans; he was going to establish a spa to rival those at places like Cheltenham, Tenbury Wells, Tunbridge, Leamington, and the money would roll in. The plan was to use a spring at nearby Sutton, but inconveniently the spring didn't exactly gush with water and the whole plan failed.

And so, the building was sold again – several times – even at one time to be used by the militia once again (this time as barracks until the barracks at Copthorne were built) and then, at the time of the First World War, it was used as a hostel for Belgian refugees.

It was in the 1920s that it was sold yet again, this time to Morris's for their bakery and so it was then that the building was finally dismantled and rebuilt at its present site. The bakery survived for around fifty years before being abandoned and the building was to sit idle for another twenty years until it was totally restyled as the popular pub/restaurant it is today.

The Armoury today.

Barker Street

Shrewsbury has some wonderfully strange street names, so the name Barker Street hardly gets much notice. But imagine what this part of town would have been like in medieval times. For one thing the stench would have been horrendous, because it was here that the town's tanneries were located.

The tanners would first trim the skins and then rinse them in tubs of water from the river. To get rid of any hair on the skins they would then sprinkle urine over them and leave them in a warm place so that the hair would rot. The hair would then be scraped off and the skins soaked for up to three months in a mixture that could contain anything from dung to beer. Washed in water once again, the skins would then be preserved in

Barker Street.

a solution that contained the bark from oak trees – this was the final tanning process, which produced the colour in the leather, and could take anything up to a year.

And so, the name Barker Street derives from the bark of oak trees used in the tanning process.

Bellstone

It's an odd name for what is just a lump of granite. Bell stones generally are stones that, when struck by a hammer or similar object, give out a ringing sound. They were sometimes placed beside markets in medieval times, and it is thought that they were struck when traders made an agreement, although more often than not the traders probably simply shook hands beside the stone to seal a deal.

Shrewsbury's Bellstone, which sits in front of the Morris Hall in Barker Street, has however come to have a very different association. Charles Darwin, when writing his memoirs, told of how as a young boy he was shown this stone and told that there was no such stone to be found in the local geology and it had, in fact, come from the far north (the Lake District presumably), but no one understood how the stone could possibly have moved all that way of its own volition. Some years later, as a student at Cambridge, Darwin learnt about erratics or stones that were moved by ice action during the last Ice Age and, as he wrote in his memoir, he 'felt the keenest delight when I first read of the action of ice in transporting boulders and I gloried in the progress of Geology'.

Today the stone is therefore seen as an important symbol of all those other natural things around Shrewsbury that first got that young boy interested in natural sciences.

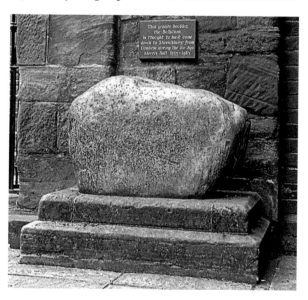

The Bellstone.

Benbow, Admiral John (1653–1702)

If you've heard of this gentleman it will probably be because his name was used by Robert Louis Stevenson in his book *Treasure Island* for the inn run by Jack Hawkins and his mother. Despite his fame in a work of fiction, Admiral Benbow was a real person. He was born in Shrewsbury in a house on the site where a new apartment block, known as Benbow's Quay, now sits overlooking the River Severn. From this land-locked county Benbow decided to go to sea, and legend has it that when he left his home he hung his door key on a nail in a nearby tree. He was away for such a long time that by the time he returned the tree had grown over the nail. This relic can still be seen in front of the modern houses on the site.

Benbow first joined the navy but later left it and eventually became captain and part-owner of a merchant frigate, *The Benbow*. While sailing in the Mediterranean Sea in 1686 he was attacked by pirates. A battle ensued and the pirates were beaten off, leaving thirteen of their dead behind. Benbow had these men decapitated, their bodies thrown overboard and their heads preserved in salt barrels as evidence of his victory. The Spanish authorities were so delighted with his success that he was introduced to the King of Spain, who not only rewarded him handsomely but also commended him in a letter to William III in England.

Benbow was then awarded a commission in the Royal Navy. By 1702 he was serving in the Atlantic as commander-in-chief of the West India Squadron when he engaged in battle with the French fleet. During the fray one of Benbow's legs was shattered by chain shot, but he still continued to take command of the battle from a hammock hastily slung up on the deck of his ship.

> O the guns they did rattle and the bullets did fly,
> But Admiral Benbow for help would not cry.

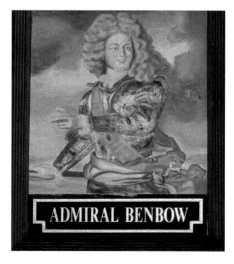

Admiral Benbow's portrait on pub sign in Swan Hill.

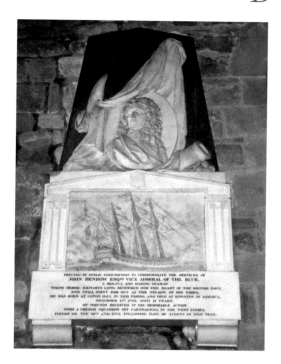

Benbow's memorial in St Mary's Church.

By now, however, his ship was so badly damaged that she was obliged to retire, so she made her way to Port Royal where Benbow died. He was buried in Kingston, Jamaica, and there is a memorial to him in St Mary's Church in Shrewsbury. A few days after his death a letter arrived from the Admiralty informing him that he had been promoted to the rank of Vice Admiral.

Benbow, Captain John

Another John Benbow was also born in Shrewsbury, but rather earlier – around 1610. The exact relationship between the two men is uncertain, but certainly there was some familial relationship there. This John Benbow joined the Parliamentarian army soon after the Civil War broke out and, with his local knowledge, it is no surprise that he was one of the leaders of the assault when Shrewsbury was taken in 1645. In fact, the town was taken very easily, which has led to a tale that there was someone within the town who opened the gates to the attacking force – hence the unofficial name of Traitor's Gate for the little alleyway of St Mary's Waterlane not far from Shrewsbury Castle. In view of the way Charles I had milked the townsfolk of all their ready cash when he came to Shrewsbury not so long beforehand, perhaps it should come as no surprise that there was someone prepared to betray the town to the king's opponents.

The interesting part of John Benbow's story, however, is what happened later. In the years that followed Charles I was captured, tried for treason, found guilty and then

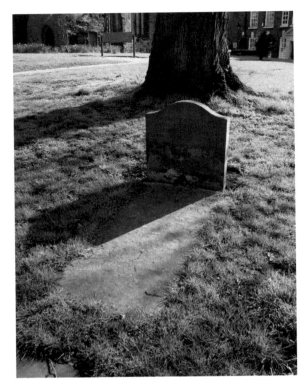

Captain Benbow's grave in
Old St Chad's churchyard.

executed in January 1649. What many people don't realise today is the dumbfounded
horror people (and not just Royalists) all around the country felt at the execution of
their monarch. So much so, in fact, that many Parliamentarians changed sides as
a direct result of the regicide. John Benbow was one such person. This meant that
two years later he was fighting for the Royalist cause at the Battle of Worcester, a
battle that was a total disaster for the Royalists. He was subsequently captured and,
of course, considered a traitor so he was then court-martialled and, inevitably, found
guilty. He was executed by firing squad in front of Shrewsbury Castle and his grave
can be found in the churchyard of Old St Chad's Church.

Bloundie Jack, Shrewsbury's Bluebeard

It is debatable when Bloody Jack, as he is now more generally known, actually lived,
but it was probably not long after the first castle had been built in the town. Legend
has it that Jack would grab young girls from the town, have his evil way with them
and then murder them. How many girls disappeared isn't known either, but Jack was
eventually caught, tried and executed on a scaffold raised at the top of Wyle Cop. Ever
since then his ghost has haunted Shrewsbury Castle where he can still sometimes be
seen dragging young maidens across the now-immaculate lawns to their doom.

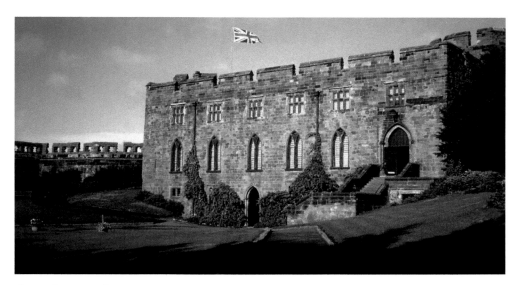

Shrewsbury Castle.

Butler, Samuel, Headmaster of Shrewsbury School

When you've wandered around the old Shrewsbury School (now the town's library) have you ever noticed the letters 'SB' on a couple of the buildings? They stand for Samuel Butler who was headmaster at the school from 1798 until 1836.

At the time of his appointment the school did not have the best of reputations, to be quite honest. It sounds to have been something of a school for hoodlums with, apparently, an average of seventy fights per week among the boys; on one occasion a riot broke out after continuous complaints about the food came to nothing. Mind you, the rioters might have had good reason for that.

Butler was only twenty-four when he became headmaster, but he totally changed the entire ethos of the school, so that by the time of his retirement it had become the equal of any other public school in the country. Not only did the school's academic reputation grow, but so too did the entire school and the buildings that bear his initials are a reminder of this development.

That's not to say that all changes were equally successful. A strict classicist himself, the curriculum of the school was very limited, something Charles Darwin was to deplore years later when writing in his memoir of his schooldays there. Butler also was not in favour of sporting achievements seeing games such as football as 'more fit for farm boys and labourers than for (the) young gentlemen' he was educating. As for those young gentlemen, they interpreted the letters SB as standing for 'stale bread, sour beer, salt butter, stinking beef, sold by Samuel Butler'.

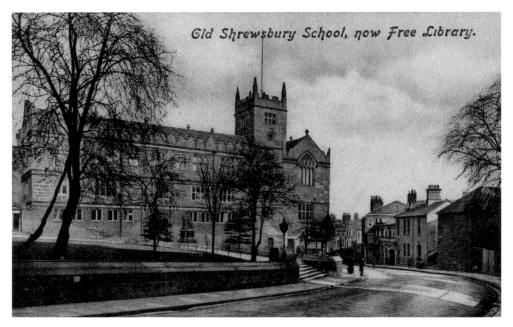

Shrewsbury Library, formerly Shrewsbury School.

Butler's grave in St Mary's churchyard.

C

Cadfael, Brother

Despite what many people want to believe, Brother Cadfael is entirely fictional. However, over the past few years he has proved to be an important draw for many visitors to Shrewsbury.

Brother Cadfael was created by the writer Ellis Peters in the 1960s. Peters, or to give her real name, Edith Pargeter, had already made a name for herself as a writer of both contemporary and historical novels. She had by this time also produced

Brother Cadfael's footprint.

a series of contemporary detective novels set in Shropshire and wondered if it would be possible to write about a detective working in medieval times who would, obviously, have had no access to modern technical advantages such as fingerprints or testing laboratories. And so she came up with Brother Cadfael, a monk living quietly in a monastery in Shrewsbury in the twelfth century. In the years since that first book was published many people have successfully followed in her footsteps with their own historical detectives, but she was one of the very first to work in this genre.

The success of the *Brother Cadfael Chronicles* is largely due to the excellent and detailed research that Ellis Peters did before she ever set pen to paper. She had carefully ensured that her detective, Cadfael, should not only be clever with his knowledge of healing, poisons and the like, but by making him a crusader before ever joining the monastery he became a man who also knew about people and understood the way they thought and acted – essential attributes for a successful detective in any era. Not only that but she placed her character in events that really happened and among people who really lived so that, all in all, the books are a wonderful introduction to a fascinating period in our history.

Cadman, Robert

Who was Cadman and how was it he came to die in 1740 in an 'attempt to fly from this high spire'?

Robert Cadman was a steeplejack who, when working on churches around the country, would augment his income by performing tricks. He had performed in many towns and was well known, having gained the soubriquet 'Icarus of the Rope' after blowing a trumpet while sliding head first down a rope from St Paul's Cathedral in London.

Asked to come and replace the weathervane on the top of St Mary's Church, he tied his rope from one of the louvred shutters in the spire to the ground. He completed his task, performing little tricks as he did so, much to the amazement of the crowd that came to watch. Then came his final trick: he wore a wooden breastplate with a groove down the centre and then lay down so that the rope fitted into the groove. And down he flew.

Unfortunately, this time the rope rubbed against the stonework of the steeple, frayed and snapped, sending poor Cadman to his death.

You'll notice that I've given a different date for Cadman's death from the one shown on his memorial. Neither date is wrong. It was some years later, in 1752, that the Gregorian calendar was introduced in Britain so that from then on our years began in January whereas in Cadman's time the new year didn't begin until March so since he died in February it would, technically, have still been 1739 when he died.

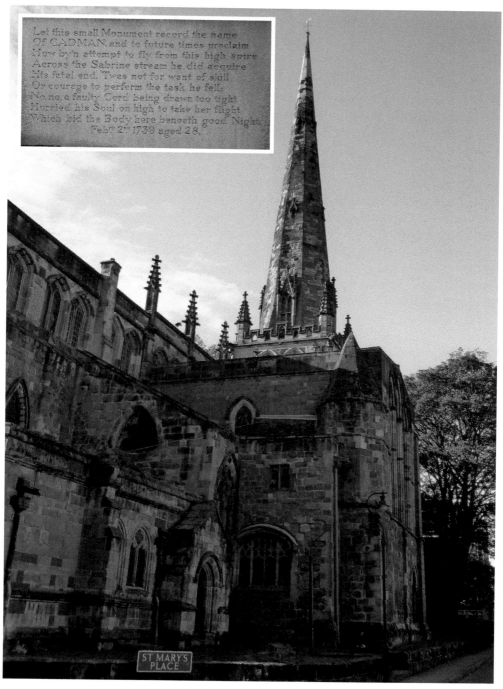

Let this small Monument record the name
Of CADMAN, and to future times proclaim
How by'n attempt to fly from this high spire
Across the Sabrine stream he did acquire
His fatal end. 'Twas not for want of skill
Or courage to perform the task he fell:
No, no, a faulty Cord being drawn too tight
Hurried his Soul on high to take her flight
Which bid the Body here beneath good Night.
Feb'ry 2nd 1739 aged 28.

Above: St Mary's Church – notice the window halfway up the spire.

Inset: Plaque to Cadman on St Mary's Church.

Carpenter's Marks and John le Carpenter

If you look carefully at timber buildings you will occasionally see Roman numerals cut into the beams. These are carpenters' marks. The timbers for these buildings would have been prepared off-site in a carpenter's yard. Once cut and shaped the beams would have been laid out on the ground and joined up to make sure everything would fit correctly. The numbers would then have been cut into them and everything would have been piled onto carts and brought to the site for erection. It was literally a case of building by numbers and was a most efficient system.

We seldom get any references to ordinary people in our early history, but there is one carpenter who gets a mention. His name, not surprisingly, was John le Carpenter. We don't know what he and his gang were paid for working on the timber façade of the Abbot's House in Butcher Row. All we do know is that at the ceremony to celebrate the completion of the building he was given a bonus of 20 pennies, which would be around 8p in modern money – how the value of a penny has changed. Apparently the wine that the abbot, the carpenter and a number of the town's dignitaries all drank cost 14 pence, so it would appear that perhaps John did rather well that day after all.

The Abbot's House in Butcher Row

Castle Museum

Although primarily a museum for the King's Shropshire Light Infantry (the KSLI), which was formed in 1881, the collection within the museum contains a number of earlier artefacts that recall the militia regiments that together were to form the later KSLI. Between them the militia regiments and the KSLI saw service in numerous theatres of war and one story that I particularly like telling our American visitors to Shrewsbury concerns the 85th Regiment, which served in the United States in the war of 1812 and, in 1814, burnt down the original White House in Washington – I have, on occasion, been asked to send them back again! (Incidentally, it is often, but erroneously, said that the White House is so named because the damaged building was painted white after the fire in order to disguise the scorch marks.)

Shortly afterwards another Shropshire regiment, the 53rd, was in St Helena guarding Napoléon Bonaparte. One memento that came back from that tour of duty was a lock of the emperor's hair, collected when he was having his hair cut one day, no doubt.

A particularly stunning piece in the collection is the baton of Admiral Donitz who, after Hitler committed suicide in 1945, briefly became president in Germany. Therefore, it was he who officially made Germany's surrender to the Allies, surrendering his baton to the commander of the 4th KSLI when he did so.

But, of course, it is the castle itself that is the oldest of all the military exhibits at the museum. It was built within only a few years of the Norman Conquest in 1066 and was to serve in a major role guarding the English border for the next few hundred years until England and Wales were united under the Tudor monarchs. Over the years it has seen many changes, culminating in the 1780s when it was converted into a very upmarket private house with Adam-style interiors – these still survive in a couple of the rooms.

A trophy of war...

Clement, Dr William James

Standing almost hidden among the trees near the Greyfriars Bridge is a memorial to Dr William Clement. The memorial once stood in a much more prominent position beside the railway station, but was moved into the Dingle in 1897 when the station was renovated. The Dingle, too, was renovated so that it finally came to rest in this little-visited spot where it was to suffer so much vandalism until it also had to be restored in 2004. Perhaps it's therefore no wonder that Clement has come be described as 'the ostracised surgeon', but in fact the reasons for the nickname go back to events during his lifetime.

So, who was he? Clement was born in Shrewsbury and educated at Shrewsbury School before going on to study medicine at Edinburgh in order to work as a surgeon. Even as a young man he showed great intellectual promise when two medical textbooks he wrote were important enough to be translated into both French and German. Returning to Shrewsbury he soon proved his abilities as a surgeon, performing tracheotomies and similar operations with a rapid efficiency that, in those days before anaesthetics, was life-saving surgery.

Unfortunately, the 1830s was a period of much political reform in the country and Clement espoused the then radical views of the Liberal party in a town that was very Tory-dominated. Feelings were so strong that many influential people in Shropshire and beyond wanted nothing to do with him and his career suffered accordingly. However, time passed and tempers cooled, so much so that Clement was eventually elected to serve as a town councillor, Mayor of Shrewsbury and even, in 1865, as an MP for the town. He died in 1870.

The Clement Memorial.

Clive, Robert

Robert Clive (also known as Clive of India) was born in the parish of Moreton Say, near Market Drayton. He was uncontrollable as a child and stories abound how, aged only seven, he climbed astride a gargoyle at the top of the tower of St Mary's Church in Market Drayton, or how in his teens he and his gang of fellow hooligans terrorised the shopkeepers of the town with threats of damage if they didn't pay up.

Finally, his father had enough and, aged eighteen, Clive was shipped out to join the East India Company as a clerk with an annual salary of £5. Checking ledgers proved to be a boring occupation and so he joined the East India Company's army. Historically, this brings us to a time when both the French and the British were vying with each other to control India, so there was plenty of opportunity for a young man of a military inclination to build a reputation. This, however, ended when the Treaty of Aix-la-Chapelle in 1748 brought hostilities between Britain and France (temporarily) to a halt.

Clive returned to trading, going into partnership with an English merchant, and his fortune started to accumulate. He married and came back to England buying a fine house in London and the estate of Walcot Hall in Shropshire. He returned to India in 1756 as a lieutenant colonel, arriving soon after the atrocity of the Black Hole of Calcutta had been carried out on the orders of a new Nawab of Bengal, Siraj-ud-Daula. Clive recaptured Calcutta and, soon afterwards, with an army that was probably outnumbered by at least ten to one, he defeated Siraj-ud-Daula at the Battle of Plassey, thus ensuring that India became part of a British rather than a French empire.

Robert Clive later became Mayor of Shrewsbury and he also represented the town as its MP. He died at the age of forty-nine at his own hands in what can only be described as somewhat dubious circumstances. Undoubtedly he had been ill, suffering from acute abdominal pains for years, and to control the pain he had been taking increasing

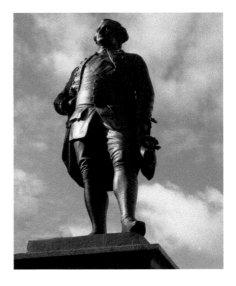

Clive's statue in the Square.

amounts of opium. It's not known whether he took his own life deliberately or whether the drugs were a cause, and it was done while under their influence. Certainly, the manner of his death, carefully hushed up by all the family, and his subsequent burial in an unmarked grave in the church of Moreton Saye in the dead of the night signals a suicide of some sort. We'll probably never know for certain. Today there is a plaque in the church as a memorial to a great, though perhaps traumatised, man.

Colonel Charles Robert Cureton

This tomb, just inside the tower of St Mary's Church, is in fact empty. Sadly, Colonel Cureton died just as he was about to leave India and return to England to retire and so was buried in India. As you will see he rose to high rank in the army, serving in the time of Queen Victoria. But the wonder is that he ever reached such a rank because years before he was in serious trouble.

Like many young officers in the army in the early 1800s Cureton enjoyed a good card game. Unfortunately, he lost. Badly. And he didn't have the means to pay his gaming debts. Other debts didn't matter (!) but gaming debts had to be paid. And so, one night he left his clothes on a beach in England and went for a swim. Everyone assumed he had committed suicide.

Cureton, however, survived. Leaving the water, he got dressed in other clothes he had brought along and soon afterwards he joined the army again, this time in the ranks and calling himself Charles Roberts. Several years later he was on parade when the officer taking the inspection recognised him. Surprisingly, Cureton was reinstated as an officer and, as we have seen, rose to the highest rank. But I don't know if that gaming debt was ever paid!

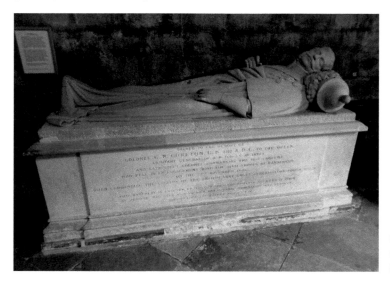

Colonel Cureton's empty tomb in St Mary's Church.

D

Dana, Revd Edmund

Believe it or not the Dana, the walk that leads from near Shrewsbury Castle over the railway line and to the former prison, is named after an American. Edmund Dana was born in Massachusetts in 1739 and how he came to give his name to a minor street in Shrewsbury is a fascinating story.

Having completed his education with a degree from Harvard University, Dana's father wanted him to become a doctor and apprenticed him to a local doctor. This didn't suit Dana who, instead, came to England and after having a wonderful time enjoying the high life in London finally went to Edinburgh University to study science. While he was there he met Helen Kinnaird. She was only sixteen, the daughter of Lord Kinnaird of Inchture and, not surprisingly, her family was not very happy when she announced she wanted to marry an unknown American who seemed to lack any ambition or prospects. The couple were married in 1765, however, and soon afterwards Dana left Edinburgh (without completing his degree) and moved on to Cambridge. Once more Dana became a student and, once again, he didn't complete his degree, but this time he did do enough work to become ordained.

Helen, fortunately for Edmund Dana, had connections and it was through these that Dana became vicar, one by one, of Wroxeter, Eaton Constantine, Harley and Aston Botterell until eventually he was vicar of all four parishes at once – one wonders how he organised his Sunday services. Another connection of Helen's was William Pulteney, who was then MP for Shrewsbury and owner of Shrewsbury Castle and, presumably, it was this connection that brought the couple to Castle Gates House where they are thought to have lived for a time.

Edmund and Helen had thirteen children (nine girls and four boys) many of whom were baptised in Wroxeter, where eventually both Helen and Edmund were to be buried. Dana, when not writing sermons, gained a reputation in the area as something of an eccentric. However, he also became a local magistrate and took an interest in the upkeep of the town's streets, which is how his name came to be attached to the Dana Walk.

Above left: Steps leading up to the Dana.

Above right: Looking back along the Dana.

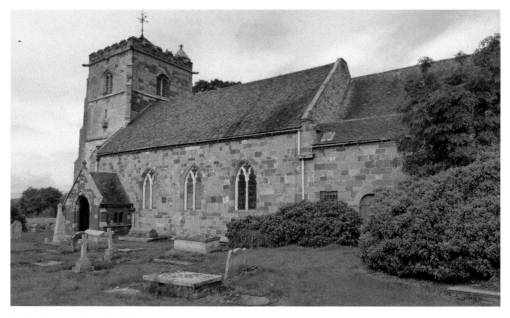

St Andrew's Church, Wroxeter.

Darwins, The

The Darwin family's association with Shrewsbury began in 1786 with the arrival of a young Dr Robert Darwin, who wanted to set up a medical practice in the town. Local legend has it that soon after his arrival the doctor (still aged only twenty) disagreed with two established local doctors as to the diagnosis of a patient. When it turned out that Darwin's diagnosis was the correct one, his practice was assured.

Robert Darwin was obviously a very clever and astute man. Within a short time he was doing well enough to start investing – this was an age when the Industrial Revolution was at its height. Over the next fifty years Darwin's investments show a clear awareness of the advances of technology at the time.

Meantime, ten years after arriving in the town Robert brought a bride to Shrewsbury. She was Susannah Wedgwood a daughter of the famous potter Josiah Wedgwood. The couple had six children and the best known, Charles, was the fifth child and second son of the couple. Sadly, Susannah died when Charles was still only eight years old. She was buried in the church at Montford Bridge, but unfortunately the exact position of her grave is lost as a result of renovations made within the church in the 1800s. In 1848, when Robert died he too was buried there, but his grave survives in the churchyard – without its iron railing surround, which was removed during the Second World War.

Robert and Susannah had a house built on the Mount by the Frankwell district in Shrewsbury and it was here in 1809 that Charles was born. As a boy no one, least of all his father and his schoolteachers, had any idea that this child would become a brilliant and world-renowned scientist. He had no interest in the academic subjects he was taught at school, much preferring to go fishing, shooting or take his dogs out rat-catching. Robert Darwin is said to have once told the young Charles that he would 'end in being a disgrace to yourself and your family'. Oh, dear!

If Latin grammar was of no interest to him then the world around him certainly fascinated the young Charles, whether it be bugs and beetles, rocks and fossils, or chemistry and ornithology. Even as a young boy Charles was following these interests and, in fact, when his school chums heard about the chemistry experiments he carried out at home with his elder brother, Erasmus, they nicknamed him 'Gas'.

In those days it was usually the case that young men followed their father's profession and so, at the age of sixteen, Charles was sent off to Edinburgh to study medicine. This was not successful. Charles couldn't stand the sight of blood and attending operations – which wouldn't have had the benefit of anaesthetics in those days – appalled him. And so, he left Edinburgh.

Instead, Charles went to Cambridge to study theology. Robert's hope was that Charles would become a country parson and be content to quietly enjoy his interests in natural history in his own time. It was while he was at Cambridge, however, that Charles met the professor who gave him the introduction to a sea captain named Robert Fitzroy who invited Charles to accompany him as the naturalist on a voyage around the world on HMS *Beagle*. And the rest, of course, is history.

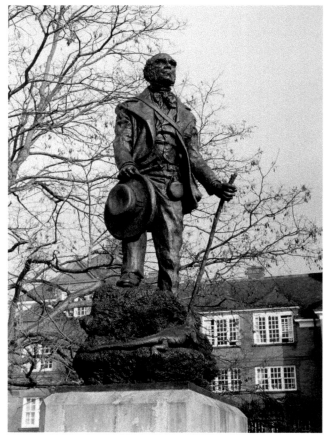

Above: Darwin House in Frankwell – Charles Darwin's birthplace.

Left: Statue of Darwin with the present-day Shrewsbury School in the background.

English Bridge

High the vanes of Shrewsbury gleam
Islanded in Severn stream;
The bridges from the steepled crest
Cross the water east and west.

This was how the poet A. E. Housman described the bridges of Shrewsbury and, with its island-like setting, the scene is perfectly portrayed.

We do not know when the first bridge was built here but we can only assume there was one quite early on in the town's history, if only to ensure that there was access to the town whenever the river was high. All we know for sure is that at some time in the twelfth century a new bridge was built. It was known for years as the Stone Bridge, which perhaps implies that there was an earlier wooden bridge, although it must be pointed out that there was already a fording point across the river (useful for those who didn't want to pay tolls for using the bridge).

In fact, the new Stone Bridge wasn't all of stone. It consisted of five stone arches over the river with, on the eastern side leading towards the abbey, a large tower gatehouse. Beyond the gatehouse there was a drawbridge and then, beyond that, a timber extension of the bridge. So, all in all, that medieval bridge must have been quite some structure, especially since there were houses on it too.

The Stone Bridge was replaced in the 1700s with a rather fine but steeply arched bridge and, to distinguish it from the Welsh Bridge leading westwards at the other side of town, the new bridge was called the English Bridge. By the early 1900s, however, that bridge wasn't suitable for the increasingly heavy (in both senses of the word) traffic. And so, bit by bit, the entire bridge was taken apart, the individual stones were numbered and shaved down, and then the whole thing was rebuilt so that the bridge was both wider and the angle less steep. Yet, the general appearance of the bridge remained the same, even to the stone dolphins on either side of the central arch. Take special note of those dolphins as you go by; when the river level reaches their mouths, beware, because the water is then also in the cellars of the houses on the riverbank.

The new English Bridge.

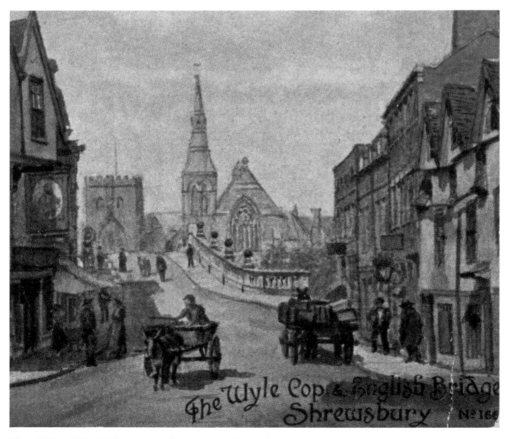

The old English Bridge – note the steep angle to the top.

F

Fire Marks

People walking around Shrewsbury often wonder what the badges on some of the buildings are for. These are usually early insurance company fire marks, but it must be mentioned that there are some badges that were placed on a few buildings a number of years ago and linked to a guidebook that has long since gone out of print.

The proper fire marks, however, are fascinating. There are three different ones to be found here, representing three different companies. One (in Dogpole) is for the Sun Insurance Company. This company was one of the earliest fire insurance companies to be founded (1706), but with only one surviving mark in town it seems to imply the company didn't have many customers here.

The other two companies were the Salop Fire Office and the Shropshire & North Wales insurance company. The Salop Fire Office was the first of these two companies,

Above left: Sun Insurance Company fire mark.

Above right: Salop Insurance Company fire mark.

Shropshire and North Wales Insurance
Company fire mark.

being founded in 1780. Interestingly, there were thirty partners backing that early company. Although each of them owned one share worth £700, they only paid up £50 at the time; but, of course, had the company ever needed the additional money they would have been liable to cover any costs. Within a year the company had issued around 200 policies and it's fascinating to note that not all these policies were for properties within the town of Shrewsbury; indeed, one early policy was made out to Abraham Darby III, the builder of the Iron Bridge, for his house in Hay Farm (now incorporated within a hotel and spa complex in Sutton Hill in Telford).

The Shropshire & North Wales Company wasn't founded until 1836, and from its start this company was intended to cover not just fire and property insurance but also life insurance as well.

It's strange to think, but these companies all still exist. This is because over the years they have merged and merged yet again with other companies so that today they are all part of that huge international firm, the Royal Sun Alliance, which provides insurance services in more than 140 countries all around the world.

Flaxmill Maltings

Shropshire can lay claim to many industrial firsts apart from its importance as the birthplace of the Industrial Revolution: the first iron wheels were made in Shropshire, as were the first iron rails, the first iron boat and, of course, the first iron bridge – the list goes on and on. Another Shropshire first, but this time here in Shrewsbury, is the world's first proper modern (iron-framed) skyscraper.

At only five storeys high it wouldn't be considered much of a skyscraper today, but one must always start somewhere. What is so important about this building is that it was the first anywhere in the world to be built using an iron frame with a brick infill. It was designed to be used as a flax mill. In the late 1700s, mills producing cloth products such as flax, cotton and wool were often subject

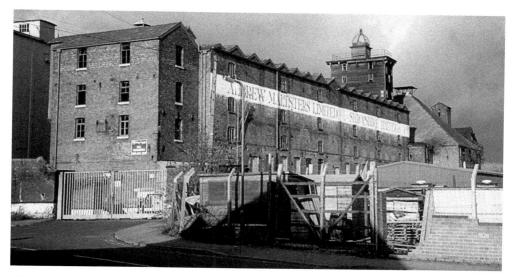

The mill before restoration.

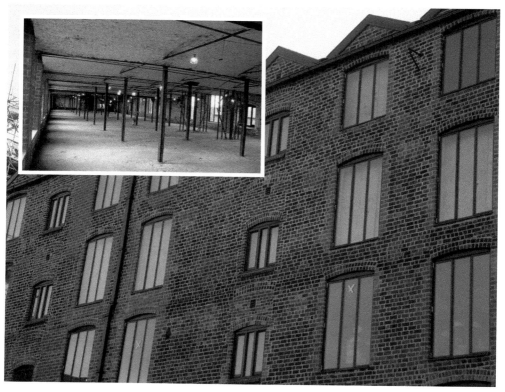

Above: The mill today.

Inset: The mill interior – notice all the iron posts.

to serious fires. It was for this reason that the architect, Charles Bage, wanted to build a structure that would be fireproof. Unfortunately, we are only too well aware these days that there is no such thing as a totally fireproof building, but in a time when timber was the main product used for such structures his thinking understandable.

The investment of £17,000 to build and equip the mill proved to be a fine one and by the mid-1800s it was one of the main employers in Shrewsbury. As a flax mill it closed in 1886 and was then converted for use as a maltings, so many of the original windows were then blocked up. The maltings subsequently closed in 1987 and the entire structure could then so easily have been demolished.

Fortunately, as the 'grandfather of skyscrapers', it was deemed to be worth protecting, and in recent years it has been undergoing restoration. Even as the work is progressing the building is often open to the public and, as one of those fortunate enough to have visited on several occasions, it has been fascinating to watch the progress from footings to roof over the last few years.

Floods

Almost entirely surrounded by the River Severn, it's the river that has had much to do with Shrewsbury's success as a trading town right from its very beginnings. That river, however, may have been useful for transporting goods (and people) over the centuries, but there were often times when it caused problems. There would have been frequent summer droughts when even flat-bottomed boats couldn't have moved up or downstream.

Then there were the winters that brought severe flooding. And it's still a problem today. Following severe flooding in 2000 flood protection walls were

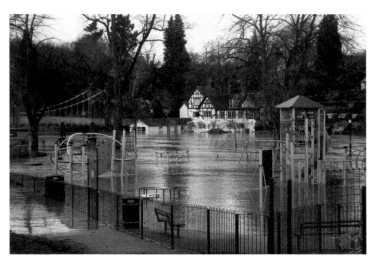

No one can play in the playground today.

built around some parts of the town, but this still left many areas vulnerable as was seen only too clearly twenty years later when much of the town became inaccessible. It's true what they say about one man's flood protection causing the next man's flood.

Flower Show

In 2005, it was stated by *Guinness Book of Records* that the Shrewsbury Flower Show was one of the longest-running flower shows in the world, and certainly the longest running in the same location. The first flower show was held in the Quarry in 1875 and cost £375 and, apart from breaks during both the First and Second World Wars, had been held every August since then, at least until the coronavirus pandemic caused it to be cancelled in 2020 and 2021.

However, 1875 didn't really see the true beginning of this event. It's a tradition that could be said to have begun in medieval times when fairs of all types were regularly held by various trade guilds in towns up and down the country. These were an opportunity for the younger workers to get the day off and really let their hair down, so they soon gained a reputation for disorderly behaviour and finally were banned altogether in the late 1800s.

Meanwhile, in 1836, a Carnation and Gooseberry show was held in Frankwell. It was extremely successful, attracting some 5,000 visitors and traders to the town, and from then on flower shows started to become really popular throughout the country so that the newly established Shropshire Horticultural Society was founded and held its first flower show in 1857.

The Shrewsbury Flower Show continues to flourish with anything up to 500 exhibitors each year attracting some 20,000 visitors to the two-day event.

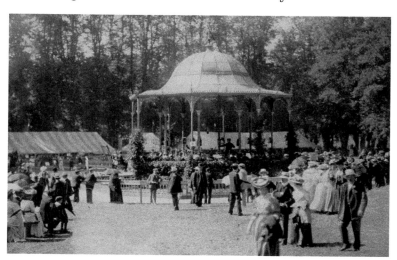

Flower Show in
the early 1900s –
notice all the hats.

Guilds

Once you start to learn about medieval history in this country you soon learn also about the importance of the guilds in controlling trade in and around England. This was very true of Shrewsbury, but whereas in many towns there are reminders of a number of different guilds all associated with different trades, in Shrewsbury there was one guild that truly dominated and could be said to have controlled business in the town and that was the Drapers Guild.

We have no idea just how old the Shrewsbury Drapers Guild actually is. All we know for certain is that there must have been such an organisation in the town by 1204 when

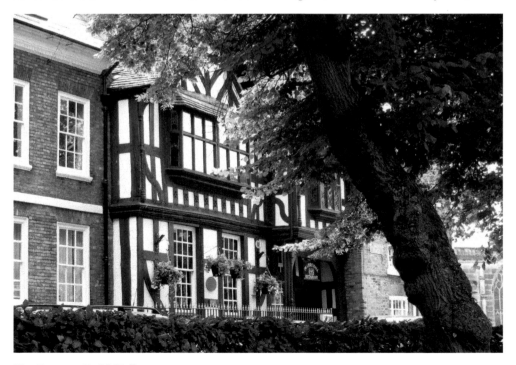

The Drapers Guild Hall.

Home of the former Fellmongers (or Sheepskin Traders) Guild.

the existence of drapers (woollen cloth merchants) is first recorded. By 1444 the guild was wealthy enough to be founding almshouses in the town, but it was only in 1462 that the Drapers Guild was formally recognised with the incorporation of a royal charter.

From then on it became more and more powerful. To my mind, however, the most fascinating thing about this guild is that it still exists to this day and members of the guild continue to hold their meetings in their Drapers Guild Hall, which dates from the late 1500s.

But that's not to say it was the only guild in Shrewsbury, despite my earlier comment about its powerful position. Other trades were recognised too and had their own guilds, from carpenters and bricklayers to tanners and ironmongers.

Harley's Stone

In times past there was usually an area of common land near a town or village where the local people could safely leave their animals to graze. However, such animals were often not free to wander where they wished but needed to be kept tethered so that they didn't stray, especially near a town.

Here in the Quarry in Shrewsbury over time certain local families acquired the right to permanently use different plots for their own animals and to mark their plot they used a large boulder to which their animal could be tethered with a rope of up to 16 yards (14.65 m) in length.

In the 1700s, when the land was bought by the town's corporation in order to establish the open parkland, all but one family happily sold the rights to their plot. The family that refused was a family named Harley that lived near Bicton and so, although the use of the land was taken over, they kept their stone here in order to remind people of their ownership. I wonder if the family still owns it.

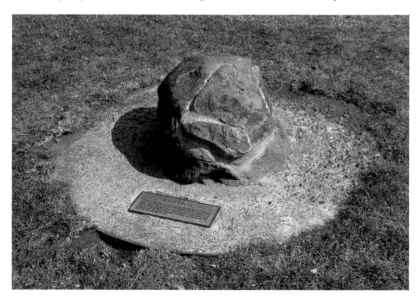

Harley's stone.

Hill, General Lord Rowland

It is General Lord Rowland Hill who stands atop that column, the tallest freestanding Doric column in the world, in front of the Shire Hall in Shrewsbury. Hill was born in Prees in 1772, the second of sixteen children. He joined the army at the age of fifteen and was a captain by the time he was twenty. But it was in the Peninsular War, under the Duke of Wellington (or Sir Arthur Wellesley, as he still was at the time) that Hill made his reputation.

At a time when the common soldier was considered to be nothing more than 'the scum of the earth' (a phrase actually used by Wellington on one occasion) Hill also was notable for his care towards the well-being of his men. He was present at the retreat

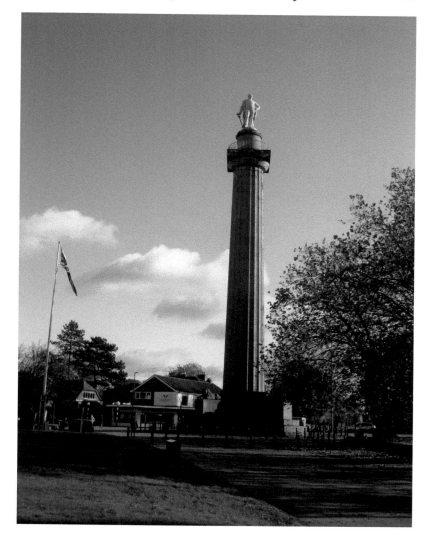

The Column.

Above: Memorial to Lord Hill in St Mary Magdalene's Church, Hadnall.

Left: Memorial window, Hadnall.

from Corunna in 1809 where he ensured that all his wounded men embarked before he, too, escaped. He also was instrumental in ensuring that disabled soldiers received pensions rather than just being thrown out of the army with no means of support as was still the norm at the time. It was perhaps because of this that his men nicknamed him Daddy Hill.

But most important of all, Rowland Hill was someone whom Wellington knew he could trust – apparently, Wellington once said of Hill that he was a man who 'knew when to obey orders and when not to'. Consequently, when given a command Wellington knew that whatever task he had been set would be carried through. In fact, such was his trust in Hill that at the Battle of Waterloo it was Hill (rather than Lord Uxbridge who was in command of the cavalry and so, technically, was more senior) who was put second-in-command and delegated to take over should Wellington himself be incapacitated.

Instead, it was Hill who was nearly killed at Waterloo, having his horse shot from under him during an attack by Napoléon's Imperial Guard. Incidentally, three of his brothers (Thomas, Robert and Clement) were also present at that battle and they all survived too. It is also said of Lord Hill that he 'used profanity on only two occasions'.

Henry VII

There's a wonderful story (apparently documented at the time) about Henry's arrival in Shrewsbury in 1485. He was making his way from Wales to fight against Richard III at Bosworth Field and Shrewsbury was the first major town in England that he reached. On his arrival here he demanded to be admitted to the town but the provost of the town, a man called Thomas Mytton, refused to let him in, saying, 'I know no king but Richard. Henry Tudor shall enter this town only over my belly.'

The townspeople were appalled at Mytton's defiance. They were well aware that Henry would then let his army fight its way through the streets and cause immense damage, so they persuaded Mytton to back down. But how could Mytton do so without being seen to go back on his word to his king? It was very simple really, Mytton just went and lay down on the Welsh Bridge, allowing Henry Tudor to literally step 'over his belly'. Honour was satisfied and Henry subsequently stayed in the house on Wyle Cop that now bears his name. He then marched to Bosworth where he defeated Richard III, thus becoming Henry VII, our first Tudor monarch.

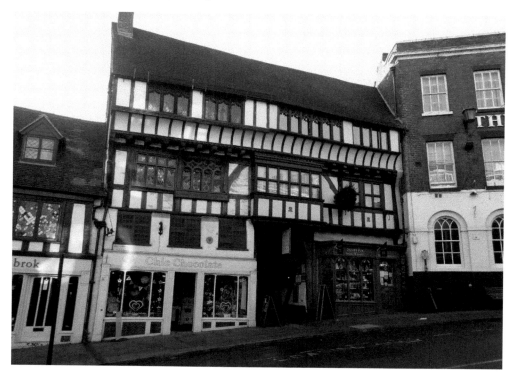

Henry Tudor House, Wyle Cop.

Incorrect Plaques

I just love it when I find plaques that proudly give information that is incorrect. We have two such plaques in Shrewsbury that I know of. With one the information was deliberate, but with the other...

Look at the plaque on the English Bridge; it tells you that Queen Mary opened the bridge on 13 August 1927. In fact, she had no idea at the time that this was what she was doing. The original bridge had been erected in the 1700s but by the 1920s it needed to be both widened and the steep gradient lowered for modern traffic conditions. The plan was that the new bridge would be opened by the Prince of Wales, but the prince had to cancel and there was the problem of who could officially open the bridge instead.

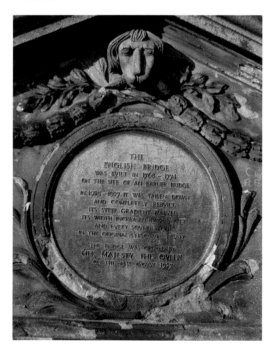

The plaque on the English Bridge.

Thomas Telford sculpture with
his incorrect birth date.

Then some bright spark recalled that not long beforehand Queen Mary had made
a private visit to Shrewsbury. The bridge hadn't been quite finished at the time, but
had been made possible for her to drive across it (the first person to do so) and so the
decision was made that this would be considered the official opening of the bridge.

As for that second error, it's on the sculpture beside the junction where the road
from the Mount meets the Shelton Road. The sculpture recalls the history of the area
with Roman soldiers, some medieval travellers and Owen Glendower supposedly
sitting in a tree watching the Battle of Shrewsbury. Also on the sculpture is a picture
of Thomas Telford whose date of birth is given as 1758 when, in fact, he was born the
year before.

Not so much a plaque, but another incorrect date, this time in Roman numerals. It's
on the cross at the top of Pride Hill and should read 1952 (MCMLII, the date the cross
was unveiled) but instead reads MCMIII. I leave it to you to work that one out!

Judge Jeffreys, Baron of Wem

The association of Bloody Judge George Jeffreys with Shrewsbury is slight to say the least: he was born in nearby Wrexham and then attended Shrewsbury School. He was only at the school for around four years before being sent on to St Paul's in London.

He's not exactly an old boy to be proud of; however, it must be said that he had a brilliant mind. He studied law and soon gained a reputation as a 'master of cross-examination'. Consequently, he rose rapidly in his profession so that he was still only thirty when he became Recorder of London and just thirty-three when he was appointed as Lord Chief Justice of England.

His decline could be said to have been equally rapid. The 'Hanging Judge' was a name he soon acquired once he was put in charge of the trials that followed the Monmouth Rebellion against James II. It is said that on one day alone he condemned nearly 100 people to death in Dorchester. With the accession, however, of William and Mary he soon lost power. He tried to leave the country disguised as a sailor, but he was recognised in the London docks and captured. He died while in prison awaiting his own trial.

It was when he was rising to power that Jeffreys bought the manor (and, hence, the title) of Wem and Loppington (for £9,000), but it is understood that he never even visited either place.

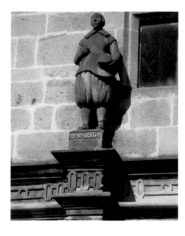

A schoolboy of Shrewsbury School, in the uniform of the 1600s.

K

Kingsland Bridge

As a town that's almost completely encircled by the River Severn, access would always have been important. At first, with a river that was subject to both flood and drought, the fords would have been usable only during times of relative calm so that two bridges (from east and west) were built early in medieval times.

The Kingsland Bridge, however, came much later as a direct result of the establishment of suburbs and the school on the southern side of town. It was (and still is) a toll bridge, and after a great deal of pushing for permission to build it was opened

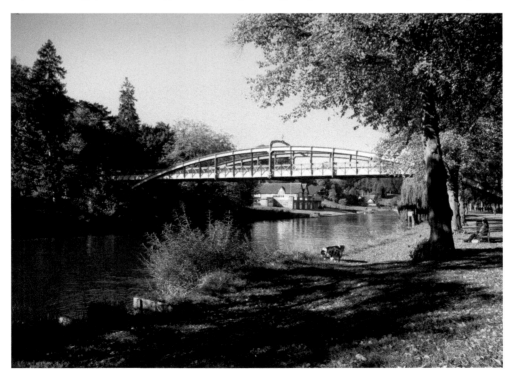

The Kingsland Bridge today.

in 1883. It has a span of 212 ft (64.6 m) and cost £11,156. It also is rather higher than the other two bridges and over the years has frequently provided the only vehicular access to the town in time of floods.

It was its height over the river that, in July 1917, gave Shrewsbury people who had come to watch a boat race an experience never previously imagined. The *Shrewsbury Chronicle* described it as follows:

> The Boat Race was in progress when attention was riveted by the wonderful manoeuvres of the occupants of two huge biplanes. The airmen ... alighted in the School grounds. The multitude waited patiently, and an hour later were privileged to witness a magnificent flying display which culminated in the more daring of the two airmen passing under the Kingsland Bridge no less than eight times and once from the opposite direction.

The pilots had come from the training station for the newly formed Royal Flying Corps (the RAF wasn't founded until the following year), which had been established only a month beforehand at nearby Shawbury. So, next time you wander past the bridge, stop and consider what an incredible feat of precision flying that must have been, and in one of those early aeroplanes too.

L

Laura's Tower

So, who was Laura and why is this tower named for her? Laura was the daughter of Sir William Pulteney who was MP for Shrewsbury. Pulteney has been described as the 'richest commoner in England' in the late 1700s and, apart from any political influence he may have had, was to prove to be a powerful patron for Thomas Telford.

At that time there was a ruling that all MPs had to have a property in the constituency they represented – now there's a good idea, perhaps they should bring that one back. Accordingly, Pulteney had purchased the then almost derelict castle and so it was he

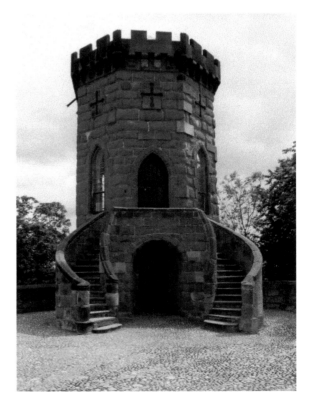

Laura's Tower.

who first brought Telford to Shropshire, ostensibly simply to renovate the castle and make it habitable. While he was here Telford soon became involved in many other projects, but one that must have been rather fun for him was the building of this little gazebo. It was a coming-of-age gift in 1790 for Laura, somewhere where she could write her letters, do her embroidery or simply gossip with her friends. It's a delightful little building with Robert Adam-style internal decoration, but unfortunately the floor is now unsafe and so it is cannot be opened to the public.

Lee, Rowland, President of the Council in the Marches

When Henry VIII decided to go against the rulings of the Church and marry his mistress, Anne Boleyn, it must have given the priest who officiated at the ceremony a bit of a problem. Did he do as the king wanted or did he refuse in order not to go against the pope in Rome? Rowland Lee was the priest who performed the ceremony, and he was well rewarded for taking the risk as, soon afterwards, he was elevated to become Bishop of Coventry and Lichfield.

Not only that, but he was then put in charge of the administration of Wales and the Marches, becoming the President of the Council in the Marches. Lee arrived in Ludlow to take control and soon put the fear of God (and of Bishop Lee) into the populace. It is said of Rowland Lee that, during the course of his nine-year reign of terror, he ordered the hanging of some 5,000 people so that it was no wonder that it was said at the time 'all the thieves of Wales quaked with fear' when Lee was in charge.

Lee was travelling from Ludlow to Chester (which was then part of his diocese) when he fell ill in Shrewsbury and died. He was buried in Old St Chad's Church.

Memorial to Rowland Lee at Old St Chad's Church.

Lion Hotel, Coaching Inn Extraordinaire

When, in the early 1800s, Thomas Telford was working on a route from London to Holyhead there was the question of just how he should go through Wales: should he take the road along the northern coast via Conwy or, alternatively, through the hills of northern Wales via Betys-y-Coed? It was the then proprietor of the Lion Hotel in Shrewsbury who may well have helped him make his decision.

That proprietor was a man called Robert Lawrence and he was obviously aware of the importance of such a route and the potential trade it would bring to towns along the way, towns like Shrewsbury. The Lion Hotel had, by this time, already built up an important sideline as an embarkation point for stagecoaches travelling not just to London but also to towns in all directions from Shrewsbury rather than just as a stopping place where horses were changed.

In those days, just as steam trains were later to be given names, coaches were often given names, and this was especially the case for coaches travelling along the most important routes. One such coach was the *Shrewsbury Wonder*, travelling the road to London with a driver called Sam Heyward holding the reins. It's said of Heyward that he would start from London at 6.30 a.m., have a twenty-minute stop for breakfast, another of thirty-five minutes for a meal in Birmingham and then on to the Lion where he arrived at 10.30 p.m. And he was never more than fifteen minutes late. How many travellers can count on that kind of punctuality these days, I wonder?

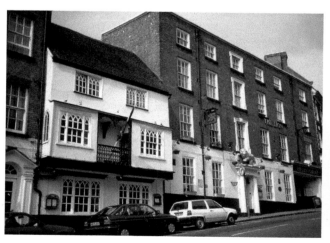
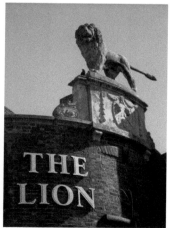

Above left: The Lion Hotel.

Above right: Statue of the Lion that stands over the ballroom.

Lock, Eric

Sadly, many remarkable young men were lost during the course of the Second World War and among them was a Shropshire man named Eric Lock who became one of the RAF's most successful British-born pilots. 'Sawn Off Lockie', which he was known as because he was so short, was born in the suburb of Bayston Hill just to the south of Shrewsbury. In 1939, when it became apparent that war was likely, he joined the Royal Air Force Volunteer Reserve since he felt that, if there was going to be a war, he wanted to ensure that he became a pilot.

He trained to fly Spitfires and qualified in May 1940, just in time to fight in the Battle of Britain. Within a few months he was to become one of the RAF's most successful pilots in the Battle of Britain, shooting down sixteen aircraft. Even though he died four years before the end of the war he was still just outside the top ten of the RAF highest scorers during the whole of the Second World War. He died when his plane came down somewhere over northern France. The plane has never been found and so he has no known grave. There is a memorial to him in the church at Condover and a street that bears his name in Bayston Hill.

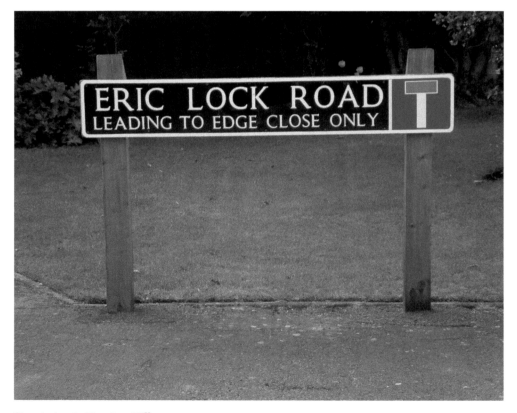

Street sign in Bayston Hill.

Loggerheads and other Coats of Arms

The old coat of arms of the town of Shrewsbury is known locally as the Loggerheads, but where could such a nickname come from? No one really knows. All we know for sure is that the three cat's heads have been used from very early times. But are they lions, as some people say, or are they leopards? They are leopards.

So why, considering that some of the coats of arms depict cats with decidedly hairy manes, am I so sure about the leopards? Apparently, in early heraldry, lions were usually used as supporters on the sides of the devices and shown full-bodied and in profile, whereas leopards were more likely to be used face-on. And that, really, is all we know for certain.

But that still doesn't explain where we get the term 'loggerheads' from. There are a number of different explanations. One suggestion, among the many, is that heads like these would have been carved at the ends of battering rams, which were then used to bash castle gates and doors down so that carving them beforehand all seems a rather pointless exercise to me. But that still doesn't explain the term here. The answer is that originally it was a form of a pun on the term leopards' heads. I know, it sounds weird, but we English have always loved playing with our language and twisting words around and that, quite simply, is probably what happened here.

While on the subject of coats of arms, there are two particularly fine royal examples on buildings in Shrewsbury. There are several differences between them, but one change is especially important. The coat of arms on the old market hall in the Square shows the Tudor coat of arms with an English lion on one side and a Welsh dragon on the other. Then the coat of arms on the library, which dates from Stuart times, has replaced the dragon with a Scottish unicorn. I like the way that both the lions have their tongues sticking out as though to show their superiority over us all.

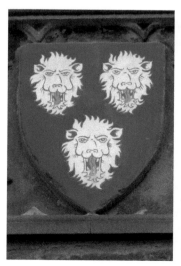 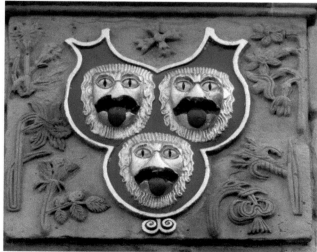

Above left and above right: Two sets of rather hairy leopards.

Mardol and other Curious Street Names

There are some truly curious old street names to be found in Shrewsbury and for many of them the derivation has been completely lost in time. But that doesn't stop us from trying to come up with explanations.

Mardol is such an example. When the word is broken down and the separate elements considered, one suggestion is that the 'mar' comes from the Welsh '*mawr*' meaning great; or was it from French '*mur*' meaning wall? As for the 'dol' element – a 'meadow'. So how can we make sense of that combination of words? Mind you, I like a rather different suggestion that the word comes from Old English words for 'boundary' and 'Devil'; it's intriguing but, again, it doesn't make much sense.

And while on the subject of odd street names, how about Dogpole? Again, no one seems to have much idea and the true explanation, whatever it may have been, is lost in time. Then there are other names like Pig Trough – I always smile when I see that one. And speaking of pigs, St John's Hill was once known as Swine Market Hill because that's where the swine market was, but the name was changed in the late 1600s when the area was developed and became more upmarket.

I particularly like the name Wyle Cop because it's a reminder that Shrewsbury, through history, has been an important trading town where people of two cultures (Celtic Welsh and Anglo-Saxon English) met and mixed. 'Wyle' comes from an Old Welsh word meaning the 'way' or the 'road' while '*cop*' was a Saxon word for the 'top' or 'head', so in its entirety the street name translates as 'the road up to the top' – and most appropriate it is, too, when you've walked quickly up that steep hill.

Murivance, however, is rather later. In this case 'mur' really did mean wall and 'vance' comes from the French word '*avant*' meaning 'before' so this is the street just before (or inside) the town walls.

And don't let anyone tell you that Featherbed Lane is so named because it's where feather mattresses were spread out for the wounded from the Battle of Shrewsbury to lie on. Feather mattresses were expensive, and no one would have let people bleed all over them. Instead, the reference to a feather bed reminds us that the ground there is marshy and soft, so like a comfortable feather bed.

Street signs.

Market Halls, Old and New

We are blessed in Shrewsbury, we have two market halls. It must be admitted, however, that only one still serves its original purpose.

Our first market hall was built in the Square in 1596. Largely financed by the Shrewsbury Drapers Guild, it was built to serve a double purpose with an open ground-floor market for the general public while the upper floor was used by the drapers as their cloth market.

One curiosity on the building is the funnily carved section of stone in one of the inside walls of the open-air market. People generally ignore it when they walk by, if they even see it that is, and if they think anything of it at all they often assume it is some kind of airbrick. It is, in fact, a counting frame, but the strange thing about it is that with ten holes horizontally and five vertically it could be considered as a decimal counting frame, but in an age when there were 12 pence in each shilling and 20 shillings in each pound just how did it work? It can't have been used for financial transactions, surely. I'm sorry but I can't help you with an explanation. I've been given several different ones and have to admit that I am not sure about the veracity of any of them. All I can say is that to use it you would have needed small wooden pegs to slot into the various holes as you counted up.

Today the old market hall has a dual purpose, serving as both a cafeteria and a cinema. Meanwhile a replacement market hall was built nearby in 1869. This was an

over-ornately designed typical market of its period and by the 1960s was rat-infested, totally rundown and in dire need of improvement. Not that many local people felt at the time that the modernist building that replaced it was in any way an improvement.

It has taken a number of years but at last the new market hall has come into its own, so much so that in 2018 it was voted the best market in the country.

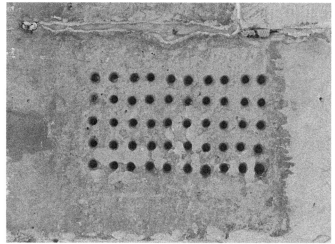

Above: View from under the Market Hall.

Left: The counting frame.

The new Market Hall.

Morris Lubricants

Employing around 230 people in Shrewsbury, Morris Lubricants is proud of its reputation as one of the largest privately owned such companies in Britain. In 2019, the company celebrated its 150th year of trading and, believe it or not, this oil-producing company actually started all those years ago as a grocery store in Frankwell.

Victorian grocery stores didn't just sell foodstuffs but other household goods as well; for example, in that early Morris shop candles were also sold and, in fact, soon after the shop opened the Morris family started a candle factory in order to supply their shop.

But this was a company that looked to keep up with changing customs, so as interest in candles declined with the introduction of parafin lamps, the company started to sell parafin as well. The 1890s saw tremendous expansion in the variety of products the company dealt with: a bakery was established and they started selling wines and spirits too. They also sold oil for paints – in those days paint was usually sold in powder form so that you needed to purchase oil separately in order to mix up your paint. Then, just before the First World War, they opened a café in Pride Hill, which soon became extremely popular for its tea dances.

It was the association with oil, however, that was eventually to be most important as, from the 1920s onwards, there was an increasing demand for petrol-powered vehicles of all types so that from then on it wasn't just oil to mix paints that was sold by Morris's.

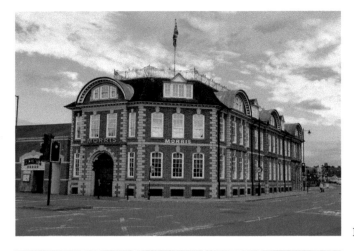

Morris & Co. head office.

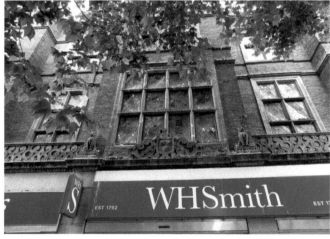

WHSmith – once home to the Morris café.

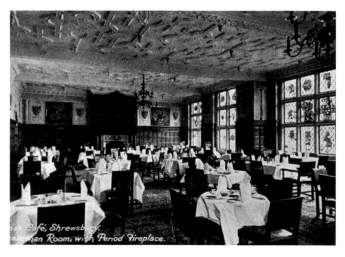

The room beyond the windows – notice the wonderful plaster ceiling.

N

New St Chad's Church

There are two churches in Shrewsbury dedicated to St Chad – the old and the new. Old St Chad's was a Saxon foundation, although the church there was fully rebuilt in Norman times. I was once told never to ask if a Norman church tower or spire fell down but, rather, to ask when it fell – the foundations of those first churches were never strong enough to support the additional bits that over the years were added on top. Inevitably, Old St Chad's tower collapsed one night, bringing much of the rest of the church down with it. Today only the former Lady Chapel of the church survives.

And so, New St Chad's was built. There's a wonderful story about how the design of the new church came about. Apparently the architect George Steuart submitted four plans, three of which were cruciform in shape and one of which was for a church with a round nave. The parish council wanted to stick with the cruciform style with which they were more familiar but, so the story goes, they didn't specify this in the minutes of their meeting and so Steuart, wanting the more modern design, went ahead with plans for the round church. When the council saw the foundations and realised their error it was too late to change. How much of this story is true is debatable, but

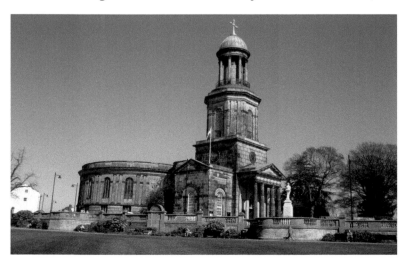

New St Chad's
Church.

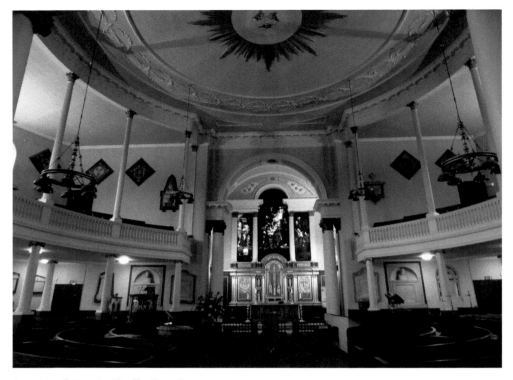

Interior of New St Chad's Church.

I strongly believe that there is usually a grain of truth hidden somewhere in such local legends.

And so a wonderful, round, baroque-style church using the then very modern technology of iron columns came to be built. Despite that early prevarication over its design the church is now well loved by Shrewsbury people.

Incidentally, the dedication of the church to St Chad came about because Shrewsbury sits in the diocese of Lichfield Cathedral, which has the same dedication. It was St Chad who, in the seventh century, really established Christianity in the kingdom of Mercia, which then stretched from the Welsh border to the Wash.

O

Owen, Wilfred (1893–1918)

Wandering around Shrewsbury Abbey you may come across a rather odd-looking memorial and wonder just what it signifies. It represents a pontoon bridge that was being constructed across a canal in war-torn France by some soldiers one day in November 1918. The officer in charge of the task was a local man, Wilfred Owen, whose parents lived a short distance away in Monkmoor Road and he was shot that day by a sniper. Seven days later the war ended.

Look more closely at the memorial and you will see, beside Owen's name and dates, a line from one of his best-known poems titled 'Strange Meeting'. At the time of his death Owen was completely unknown as a poet except among his close friends so that he could never have imagined the fame his work has since achieved. Speaking for myself, I had to study his poems as part of my A level English course and, though much of the other coursework I've since happily forgotten, I've never forgotten how moved I was by this man's poetry.

I make no excuse for including a photograph of a superb statue of Owen that is not to be found in Shrewsbury at all. It's actually in the Memorial Garden in Oswestry, the town where he was born. Do go and look for it, it's well worth a visit.

The pontoon bridge memorial in the grounds of Shrewsbury Abbey.

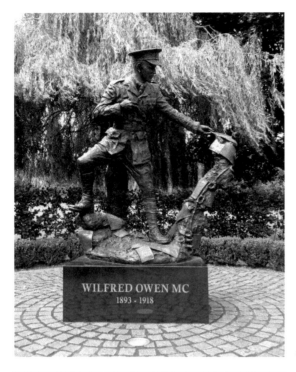

Owen's statue in Oswestry.

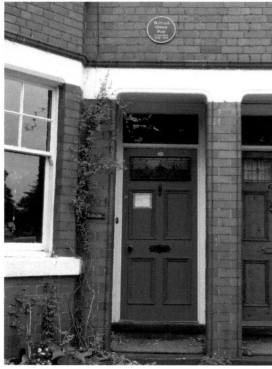

Entrance to Owen's family home with the plaque above.

P

Palin's Shrewsbury Biscuits

Oh! Palin, Prince of Cake Compounders,
The mouth liquefies at thy very name!

When she visited Shrewsbury in 1832 Princess Victoria was presented with a tin of Palin's Shrewsbury biscuits.

The traditional Shrewsbury biscuit was quite large and circular, and the biscuit mix was rolled out so that it was very thin and therefore very fragile. This meant that it was difficult to market the biscuit in anything other than a tin box. It was perhaps for this reason that we have so many variations on the recipe as people who sold them would have wanted a sturdier product that was easier to package and sell, so that nowadays it's virtually impossible to know what the original recipe actually was. However, we do know that the early biscuits probably contained spice and rosewater, although I have come across a reference to one recipe that also uses sherry. Some recipes replace the spice and rosewater with lemon juice or rind and dried fruits. It would appear that virtually anything goes with this recipe.

As for who Palin was, well, no one seems to know, and when people talk about when he started making his biscuits even then there is disagreement, with some saying they were first produced in the 1760s and some saying that they date from the early 1800s.

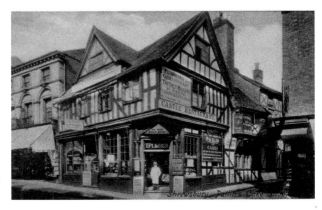

Palin's Cake Shop at the turn of the nineteenth/twentieth centuries.

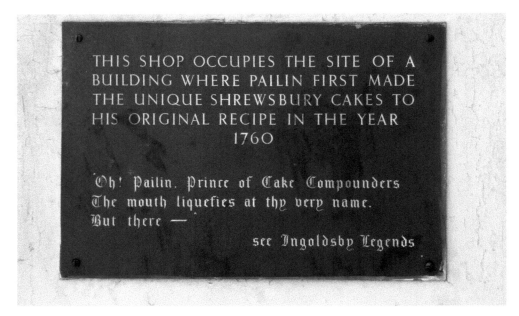

The sign beside the building today.

Pennant, Robert, Abbot of Shrewsbury Abbey

If you enter Shrewsbury Abbey from the south door you will see in front of you a plaque listing all the former abbots of the abbey starting from 1087. The fifth abbot listed is an abbot called Robert Pennant (the first to be given a surname). We don't know when he became abbot, only that he died in 1167 and previously had served as a prior.

However it was while he was a prior that he travelled to Gwytherin in north Wales in 1136 to collect the bones of St Winifred so that they could be reinterred in a shrine here in her honour. The story of St Winifred survives largely thanks to Pennant who, on his return to Shrewsbury, wrote down not just the saint's life story but also a description of his journey to collect her remains. Although his original Latin script has disappeared the work was translated into English in the early 1500s and was subsequently the inspiration for Ellis Peters when she wrote the first of her Brother Cadfael novels, *A Morbid Taste for Bones*.

Incidentally, as a character in the Cadfael novels, Pennant comes across as a rather ghastly interfering nuisance so far as Brother Cadfael was concerned. But we must remember that all we know of him is his name and about his actions in obtaining Winifred's bones and establishing her shrine. We have no idea what his true character was like; he could have been a lovely man.

All that remains of
St Winifred's shrine.

Prince Rupert Hotel

The Prince Rupert Hotel is a wonderful mixture of buildings of all ages, from its Norman cellars, through to its sixteenth-century timber and eighteenth-century Georgian additions right up to the present day. But why should it be named after a German prince, Prince Rupert of the Rhine to give him his correct title?

Prince Rupert was actually a nephew of Charles I (Rupert's mother was a sister of King Charles who had been married off to the King of Bohemia). Prince Rupert was a gifted boy who learnt all the major European languages while still a child. As a soldier he was brilliant, forging an early career fighting in Germany, but it must be said the fact that he was nicknamed 'Rupert the Devil' by his own family tells you a lot about his nature. When the Civil War broke out he promptly joined Charles I and was appointed commander of the king's cavalry. He was good-looking, dashing and soon won a reputation leading cavalry charges with his favourite dog, a poodle called Boye, sitting across his horse in front of him at the early battles at Powick Bridge and Edgehill. He was still only in his twenties and incredibly arrogant, never listening to advice from anyone and only being prepared to accept orders from the king, so he quickly alienated other Royalist leaders, leading to a lack of co-operation within different sections of the king's army and the inevitable fallout of bad feeling. He left England in 1646.

Following the Restoration in 1660, Rupert returned to England and was appointed to the Privy Council. His particular interest by now was in naval matters and he later became First Lord of the Admiralty.

As for his link with Shrewsbury, Prince Rupert used the town as his headquarters for a time, staying in Jones's Mansion, one of those early buildings that has since been absorbed into the present-day hotel.

Above: The coat of arms of Prince Rupert portrayed on the hotel sign.

Left: The Prince Rupert Hotel.

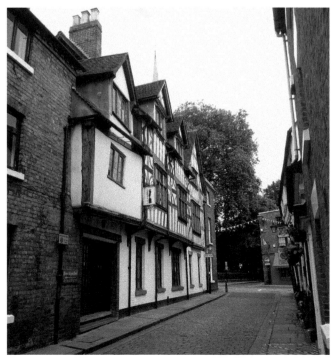

Jones's Mansion, now absorbed into a later building complex.

P

Pubs

It's been said of London (and it could be true of any town in the country) that to know its pubs is to know its history. Well, in Shrewsbury the pubs don't simply reflect the town's history, they have histories of their own.

The pub that has been running for the longest time is the Golden Cross, which is thought to have already been serving ale to its customers from around 1428. Intriguingly, the Golden Cross was once physically linked to Old St Chad's Church via an arched passageway that bridged the road between. There's one lovely (though perhaps apocryphal) story that tells how in the 1700s, when sermons often went on for hours at a time, the church wardens used to sneak through this passage and into the pub for a drink, leaving one of their fellows behind in the church ready to warn them to return just as the preacher was bringing his sermon to a close. I do hope that story is true.

Another fascinating building is the King's Head in Mardol, although its use as a pub didn't begin until the 1800s. A timber-framed building like the Golden Cross, its timbers are even earlier – 1404. Obviously, it is a lovely old building when you first

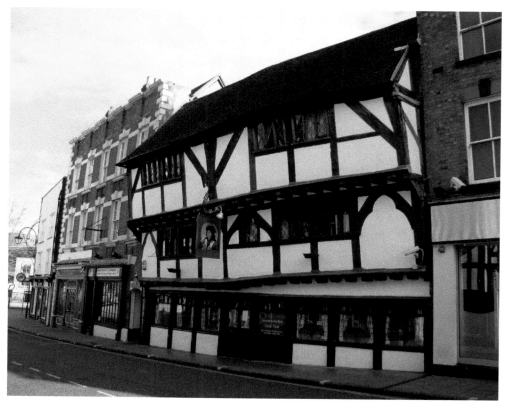

The King's Head pub.

65

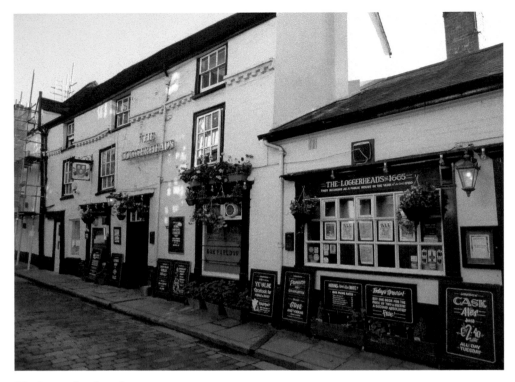

The Loggerheads pub.

see it from the outside, but its real treasure is to be found indoors: a brick wall with a painting of the Last Supper, which is thought to have been painted around 100 years later while the building was still a private house.

The Nag's Head in Wyle Cop has the remains of a medieval hall house attached at the rear while the Loggerheads in Church Street is a timber building hidden away under a later brick skin. Then there's the Dun Cow in Abbey Foregate, which is reputed to be made from old ship's timbers (a most unlikely story here in Shropshire where there was already an excellent supply of timber to be had so that there would never have been any need to haul timbers all the way upstream from a seaport).

And that's just some of Shrewsbury's pubs.

Q

Quantum Leap

Unveiled in October 2009 the *Quantum Leap* was created to celebrate the bicentenary of the birth of Shrewsbury's most famous son, Charles Darwin. The sculpture sits by the River Severn and is some 12 metres high and 17.5 metres long. The whole thing is made of concrete sections, weighs over 133 tonnes and was designed by architects, Pearce & Lal.

It created something of a discussion (!) among the people of the town when it was revealed – for one thing no one could decide what it actually was. Obviously, it was an abstract work of art, but what did it represent? Was it the skeleton of a dinosaur, perhaps it was a DNA helix? Inevitably it soon acquired a local nickname and has come to be called 'the Slinky' because of its resemblance to the coiled-wire toy.

Speaking for myself, like so many I was puzzled. Did I even like it? One day, in order to come to a decision, I went and had a good look, walked under it, studied the geological timescale on the ground beneath and finally decided that, even if I still didn't understand it, I loved it. I think it was those geological pictures that scroll around it that decided things for me; they tell us the story and emphasise the scale of the life of our planet, something we are reminded of when we consider Darwin's theory of evolution. But there's something else special about this too. It reminds us that geologically the county of Shropshire is one of the most fascinating counties in all of Britain because it contains rocks from such a variety of different geological periods, far more than any other region in Britain.

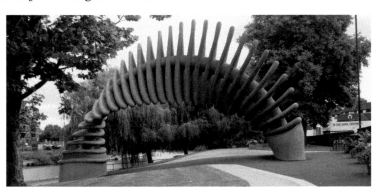

Quantum Leap sculpture.

Rope, Margaret Agnes

Visit the Roman Catholic cathedral on Town Walls and you will immediately be struck by the superb quality of the stained-glass windows. These are particularly special not only because of the high quality of the work but also because the artist of seven of the windows was local – born in Shrewsbury in 1882.

Margaret Rope was the daughter of a doctor in the town. Her father died when she was seventeen and, soon afterwards, her mother converted to Roman Catholicism, as did Margaret and four of her five siblings. After a home education Margaret went on to study art in Birmingham and developed an interest in stained glass. On completing her education she returned to Shrewsbury and set up a studio in her home, and it was from here that she produced much of her early work – one of her first commissions was for the large west window in the then newly completed Roman Catholic cathedral.

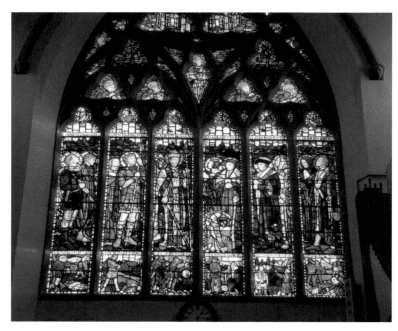

The west window
in the cathedral.

In 1923, she became a nun and, fortunately, was able to continue with her work, examples of which can be found not just in Britain but also in Italy, South Africa, Australia and the United States.

Rowing Clubs

For over 100 years Shrewsbury has had a close association with not one but two rowing clubs. Indeed, such was the interest in the sport that in 1909 a weir was built downstream of the town in order to keep the water levels around the town (that would otherwise be subject to extremes of flood and drought) at a decent height so that the river could be used year-round for boating activities.

The first proper rowing club was established in 1866 as a school boat club within Shrewsbury School, although from early days local people could also become members, with both groups sharing the school's boathouse. Then in 1871 a new club was formed, the Pengwern Boat Club. The name, Pengwern, comes from the seat of the kings of Powys in the Dark Ages, possibly on the site where Shrewsbury now stands. Sadly, this is one of those myths that cannot be proved one way or the other so that Shrewsbury is not the only place in Shropshire that lays claim to having been Pengwern.

In the years since their separation the two clubs have continued a friendly rivalry in many respects, though these days it's the Pengwern Boat Club that really comes into its own each May when it organises the Shrewsbury Regatta, attracting entries from rowing clubs all over the country.

Shrewsbury
School
boathouse.

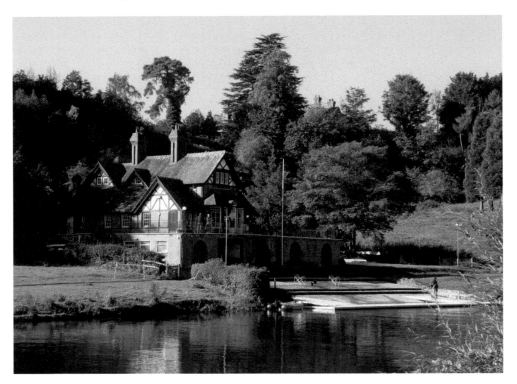

Pengwern Boat Club.

S

Sabrina, aka the River Severn

I once went for a walk searching for the source of the River Severn in the Plynlimon Hills only to discover that it is basically little more than a puddle in the middle of hilly, marshy moorland. It's astounding to realise that from this puddle, stretching for some 220 miles, you can follow Britain's longest river.

Believe it or not the River Severn originally flowed northwards and entered the North Sea somewhere near the Wirral, but then during the Ice Age its route to the sea was blocked by the ice sheet that covered northern England. Consequently, the river needed to find another route and, so turning eastwards, it carved out the gorge at Ironbridge before finally heading south and reaching the Bristol Channel.

But where does the name Sabrina come from? It's thought the name for the goddess of the river derives from an original Celtic word for the river's name, the meaning

Statue of Sabrina
in the Dingle.

Shrewsbury from the air, surrounded by the River Severn.

of which is unknown. Over the years this word translated in Welsh to become the Hafren and in English to become the Severn. Meanwhile whatever the original Celtic word was, in Roman times it developed as Sabrina and has remained ever since as the name for the deity of the river.

Sabrina has certainly looked after her river and over the centuries it has provided the townsfolk with not only water and fish to eat but also a way of bringing goods in and out of the town, so that in medieval times Shrewsbury became a major trading centre in the country. But she hasn't always been the kindest of gods, with her occasional floods that these days can still bring the town to a virtual standstill.

'Salop'

When I show visitors around Shrewsbury I'm often asked how the town's name should be pronounced: is it 'Shrows...' or 'Shrews...' or even 'Shoes...'? In fact, even the local people can't seem to decide, although that third version seems to be growing in popularity, especially among the young.

When you attempt to analyse the town's name historically, and bear in mind medieval scribes didn't care about spelling but simply wrote down what they heard phonetically, then you discover that the town's name was nearly always spelt with an 'o' somewhere in it, which would seem to imply that the original pronunciation was nearest to Shroewsbury. So why and when did it change? One story that I love is that

May Shrewsbury (Town Football Club) Flourish.

sometime in the 1300s/1400s a mapmaker made a spelling mistake and simply missed out the 'o' so that, from that day to this, people have argued about the pronunciation. Who knows? It might really have happened that way.

And where did Salop come from? That's relatively easy because it's simply a shortened version of the Latin name Salopsbury, rather like Londinium for London. The town's coat of arms bears the words '*Floreat Salopia*', meaning 'May Shrewsbury Flourish' – the word *floreat* being a Latin root that has led to a number of English words including flower and flour and, of course, flourish.

Incidentally, whichever pronunciation you choose when you say the town's name, well, you won't be right (according to some) but nor will you be wrong.

Shuts

Shrewsbury is well known for its many shuts, which are narrow little alleyways between buildings that link larger streets. They would once have been common enough in towns all over the country and are called by various names; I rather like the twittens, gimmels and snickets that you find in other parts of England. As to why they are called shuts here, well, yet again there are various explanations. Some would have it that they are derived from 'short cuts', others say that are so named because you could 'shoot' quickly through them on your way. But I think the obvious explanation is probably the most likely: being narrow it would have been easy to control access through them by simply shutting them at times; indeed, there are some that still have hinges near their entrances where gates once hung.

Today there are some twenty shuts that survive in the town out of at least 200 a couple of hundred years ago. It's their names that are so evocative. Names for shuts that have disappeared include the Snow Shoe Shut (try saying that when you've had one too many), which today is known as Peacock Passage. There was once a Fire House Passage, a Steelyard Shut and – I like this one – House of Correction Shut.

Above left: Looking up Grope Lane.

Above right: Gullet Passage.

Of those that survive there's one you might think is going to be a relatively easy stroll, but you'd be wrong – 70 Steps Shut. It was redesigned when the nearby Darwin Centre was built, so it now actually has 105 steps. And you don't need much imagination to realise what once flowed along the pathway in Gullet Passage: it served as an overflow channel that took all the muck from the pond in the Square down to the river every time there was a heavy rainfall – perhaps the reason why it has that slight river-like meander halfway along it.

But the shut that visitors to the town love walking through is Grope Lane – I always tell visitors that if they laugh when they hear the name then they have probably guessed what it refers to. Our ancestors were never shy of calling a spade a spade!

Sidney, Sir Philip

Sir Philip Sidney, whose statue tops the war memorial at Shrewsbury School, wasn't born in Shrewsbury or even, as an adult, had much to do with the town. His inclusion here is due to the fact that he attended Shrewsbury School from the age of ten. Sidney is seen today as the epitome of the chivalrous Elizabethan gentleman. He was well travelled and acted on several diplomatic missions for Queen Elizabeth in Europe. He was well educated and was the author of several

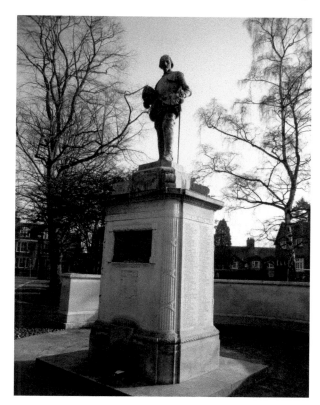

Right: Philip Sidney's statue at Shrewsbury School.

Below: Plaque showing Sidney giving his water to the wounded soldier.

poetic works, the best known of which is *Arcadia*. He was also a soldier, serving in Ireland and Europe.

It was, however, the manner of his death that was to confirm his reputation as a chivalrous knight. He was serving in the Netherlands in the Dutch cause, fighting for their freedom from Catholic Spain when, having lent his leg armour to a friend who had none, he was hit in the thigh by a musket ball at the Battle of Zutphen. Though serious, the wound wasn't thought to be life-threatening and he rode back to his camp a mile away, arriving there weak from loss of blood. He was offered water but saw another wounded soldier nearby and passed the bottle to him instead, saying 'Thy need is greater than mine.' He was later recovering from the wound in Arnhem when it festered and caused his death. Sidney's body was returned to England (in a boat with black sails), he was given a state funeral (the first commoner ever to receive such a tribute), the court went into mourning and Oxford and Cambridge universities (both of which he had attended) issued memorial volumes in his honour.

Today the town of Shrewsbury is still linked with that of Zutphen in Holland, in memory of Sir Philip Sidney although the official twinning arrangement that existed has fallen into abeyance.

St Mary's Church

St Mary's Church is both an architectural and historical gem. The church was founded sometime in the mid-tenth century and we know little about that church except that its foundations still lie under the nave of the present church. The church was then rebuilt in the 1100s and bits and pieces have been added to it ever since, making it a wonderful amalgam of styles. I often think it's a good thing there were no town planners in medieval times to say 'no' every time someone wanted to add on a new bit in a new style to an old building; time has ensured that everything now seems to meld together so well.

So what is it that makes St Mary's so special? The first thing visitors notice as they walk inside is the magnificent carved ceiling. It was, in fact, restored in the 1890s after the original roof caved in when the spire collapsed on top of it, but the wonderful thing about it is that the Victorian craftsmen who restored it used as much of the original timberwork as they could. Look up at the ceiling today and you'll see that much of the timber looks bleached, almost white in parts – those sections are thought to have been discoloured by lime mortar from the broken spire as it lay on top of the damaged roof and were subsequently reused.

Walking up the nave your eye is then drawn to all the windows with medieval glass not just from England but from the Continent as well. The turn of the 1700/1800s saw a shift in fashion towards plain glass windows in churches so that many medieval windows were destroyed. The vicar at St Mary's obviously had an eye for a bargain and bought much of the glass for St Mary's.

Is it any wonder that I call St Mary's, 'Shrewsbury's Treasure House'?

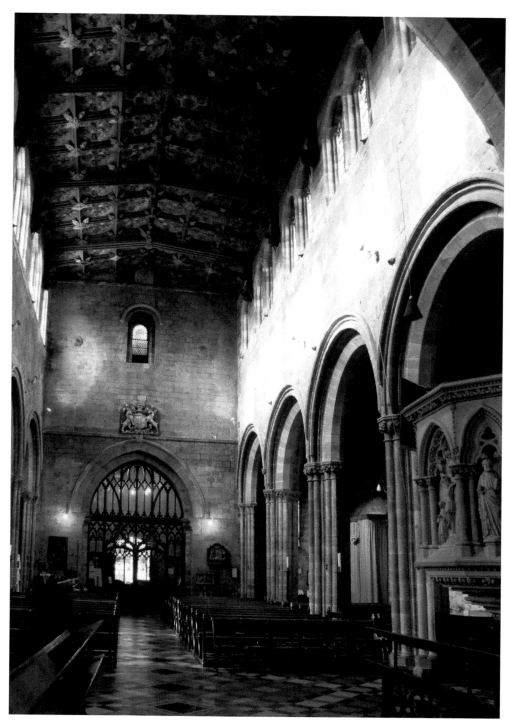

The nave in St Mary's Church with its wonderful ceiling.

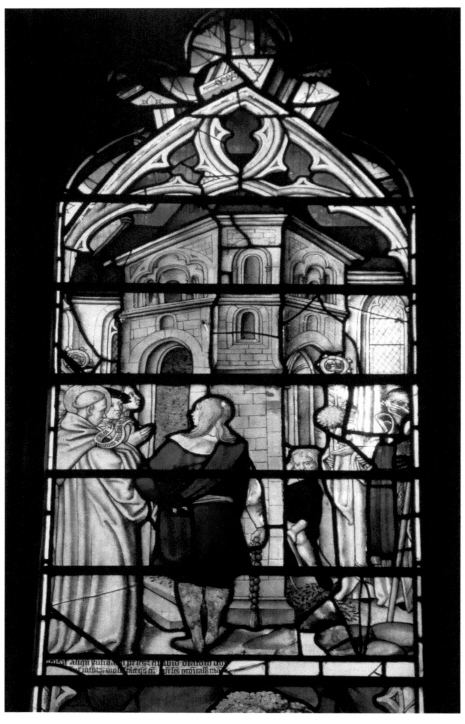

Detail of one of the St Bernard windows, originally from Germany.

T

Tanners

Recently named one of the country's 'best national wine shops', Tanners has been in business for over 175 years, starting from 1842.

Having said that, it has to be admitted that William Tanner, who founded the company, was only born in 1839 and so would have been rather young to establish a wine and spirit merchant business at that time. In fact, as a young man he went to sea and by the time he retired in the 1870s had become a sea captain. It was then that he returned to Shrewsbury and, with his brother, founded the company to sell not just wines and spirits but also ales. Over the years the company prospered and bit by bit it was to take over several other such businesses, one of which was another Shrewsbury company, Thomas Southam & Sons. It was Southams that had been founded in 1842 so that, technically at least, the company can still easily claim to have been in existence since that early date.

Tanners shop in Wyle Cop.

The only surviving Victorian shop window in Shrewsbury.

Whatever date one chooses for its birth, this is still a family business with an excellent reputation that has been built up over many years. But what fascinates me most is the building from where they trade. Thought to date from the late 1400s, one walks back in time when entering their premises on Wyle Cop, although you don't need to go inside to appreciate its history. The shop entrance on the street has the only Victorian shop façade that survives in Shrewsbury. It's a wonderful survival, although perhaps marred slightly when you look through the window and see the modern computer on the counter, but then I suppose such modern gadgets are necessary these days.

Thrower, Percy

For those who were children in the 1960s the name of Percy Thrower has come to be synonymous with the television programmes *Gardener's World* and *Blue Peter*. Perhaps largely forgotten elsewhere, these days he's still fondly remembered here because of his association with the gardens and parkland of the Quarry and the Shrewsbury Flower Show.

It was just after the end of the Second World War when Thrower arrived in Shrewsbury to take up a post as park superintendent. He didn't get off to a good start. One of the first things he did was to chop down an avenue of beautiful lime trees,

and this made him extremely unpopular. He had good reason, though, the trees were over 200 years old and close to the end of their natural lifespan and would have fallen anyway before too long. He replanted, and if you walk through the parkland today you will inevitably find yourself admiring the avenues we now have.

In next to no time Percy Thrower had built up a reputation for not just the open park area but also for the gardens of the Dingle and it was this that brought the BBC to Shrewsbury to invite him to join a radio gardening programme. It turned out that he was a radio genius. One of those rarities who, when asked to speak on a subject for, say, two minutes and fifty seconds, would do exactly that and do it so naturally that each listener felt he was speaking to him or her personally.

Percy Thrower died in 1988 having been awarded the MBE four years earlier, not to mention the numerous show medal and other awards he had been given over the years. Incidentally, he's even entered Cockney rhyming slang; believe it or not, a Percy Thrower is now a term for a lawn mower.

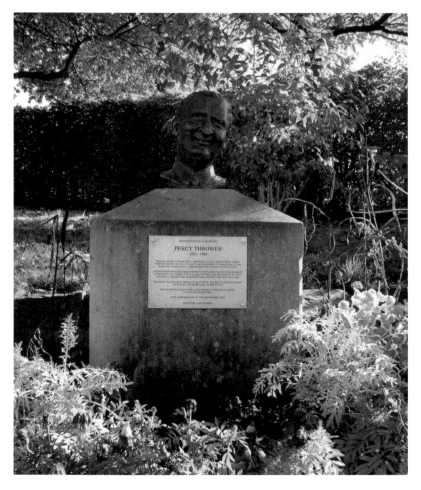

Bust of Percy Thrower in the Dingle.

The Dingle gardens.

Treason – Prince David of Wales and Harry Hotspur

Reading the plaque at the top of Pride Hill you learn of several men all of whom were executed near that spot for treason. But what are the real stories?

For a start, how could a Prince of Wales be executed for treason when fighting against invaders from another country – England in this case? Legend has it that it all really began in Anglo-Saxon times when, in a battle near present-day Bangor-on-Dee, a Welsh army was defeated by the English. The story goes that the English demanded fealty from the defeated Welsh and from that time on English kings always saw themselves as the overlords of Welsh princes.

Consequently, when David was captured during a campaign in Wales against another English force it was easy for his English captors to accuse him of treason on what can really only be described as a dubious technicality. In an attempt to give the whole process a legal validity, Edward I called for Parliament to meet in Shrewsbury so that David's trial could be carried out with due process. The trial took place within Shrewsbury Abbey and, inevitably, David was found guilty, dragged up the hill to this spot and hung, drawn and quartered. An interesting side note to the story is that the

executioner, one Geoffrey of Shrewsbury, was paid 20s (a truly huge sum) for carrying out the task.

Another execution, this time multiple, took place here 120 years later. Harry Hotspur, the leader of that rebellion, is perhaps best known these days to those who read Shakespeare's history plays. A member of the powerful Percy family of Northumberland, Henry Percy was considered one of the finest soldiers of his age. Raised from birth to be a soldier, he first went into battle at the age of eight and had already been knighted by the time he was eleven. His nickname, Hotspur, was given to him by the Scots because of the hot-headed way in which he would spur his horse into the thick of any fighting.

He was a legend in his own time, for both his prowess on the battlefield and as an honourable and chivalrous knight and this may have had a lot to do with the fact that he eventually fell out with the king, Henry IV, a man not exactly remembered for his sense of honour or chivalry. In 1403, Hotspur rebelled against the king, a rebellion that culminated in the Battle of Shrewsbury on a site that, to this day, is known as Battlefield. The battle, the first on English soil where both sides used the longbow, was horrendous in terms of the slaughter. After only three hours of fighting the outcome was finally decided when Hotspur was killed; his men fled, taking his body with them and burying it at Whitchurch.

Subsequently Henry IV ordered that the body should be dug up, brought back to Shrewsbury where it could be shown to everyone in the centre of town before being symbolically hung, drawn and quartered. Finally, his remains were distributed to various parts of the country and displayed to the world as a warning.

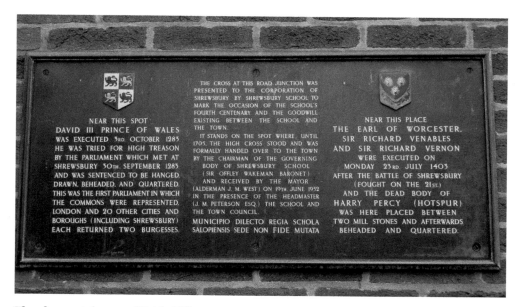

The plaque at the top of Pride Hill.

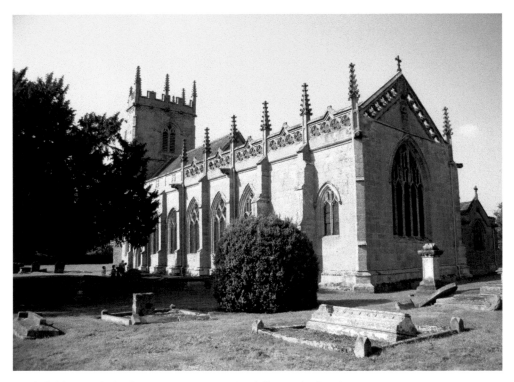

Battlefield Church, built to commemorate the fallen on both sides.

And speaking of warnings: one final story about Harry Hotspur relates how as a young man he was warned by a soothsayer that he would die near Berwick – obviously Berwick-on-Tweed to a Northumbrian. However, on the morning of 21 July as he was preparing for battle Hotspur realised that he had left his favourite sword in the camp the previous night. On ordering his squire to go and fetch it the squire replied, 'Yes, sire, I'll go straight to Berwick and get it.' It was only then that Hotspur learnt the name of the hamlet where he had spent the night and realised that he would die in battle that same day.

U

Unitarian Church

Unitarianism must be among the most tolerant of religions in the world. The movement was founded in Poland in the 1600s as an escape from the more rigid teachings of the Judeo-Christian faiths and, indeed, has proved to be ahead of mainstream thinking ever since with its encouragement of early abolitionists in the 1700s, its introduction

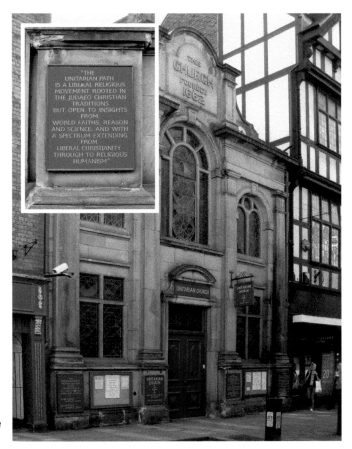

Right: The Unitarian Church.

Inset: Plaque by the entrance to the church in High Street.

of female ministers long before these were acceptable elsewhere and even, in more recent years, its acceptance of gay rights.

The church in Shrewsbury was founded in 1662, a time when Unitarianism was still not yet accepted so that the earliest meetings were held in private homes. Following the 1689 Act of Toleration it became possible to build a small chapel, but in 1715 this was destroyed by a mob. The chapel was then rebuilt at a cost of £429 16s and a halfpenny (I just love that halfpenny!). Today's church still sits on the same site.

It's hard, in Shrewsbury, to escape from links to Charles Darwin and this is the case here, too. Darwin's mother, Susannah, was a member of the Unitarian church and before her death she attended this church with her children – Charles was only eight. It's therefore highly likely that attending a church that encouraged its members to think for themselves and question the world around them would have had a profound effect on the young Darwin and his life's work.

V

Victorian (and other) Postboxes

Once, when taking some visitors around Shrewsbury there was a gentleman who showed interest in the Victorian postbox beside the old market hall. I proudly told him that we have two such postboxes in town; the other is near Shrewsbury Abbey. Shortly afterwards he drew my attention to another postbox. The Victorian ones, he told me, aren't really all that interesting as there are so many of them. 'That one, there, is much rarer,' he said, and he pointed to the postbox at the entrance to Fish Street.

Why? Well, it dates to the reign of Edward VII, whose reign was not only much shorter than Victoria's but also by the time he came to the throne so many postboxes had been set up that there was comparatively little need for new ones, so there aren't many of them around. And, yes, there are some (even rarer) Edward VIII postboxes to be found too but, unfortunately, not in Shrewsbury.

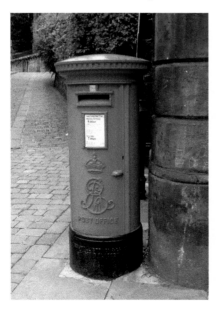

The Edward VII postbox by the entrance to Fish Street.

War Memorials

There are, sadly, numerous war memorials in churches, schools, the railway station, the police station and so on in Shrewsbury, but the main one, which remembers all those from the county of Shropshire and not just the town of Shrewsbury who fought and died in the First World War, is the war memorial in the Quarry. The first such memorial, however, was a temporary one erected in front of the town's library and dedicated on 5 August 1919.

In the meantime, money was raised for a more permanent memorial, and this was unveiled in July 1922. Within the colonnaded structure stands the figure of St Michael, patron saint of warriors; he holds a lance in his left hand and with his right hand appears to be giving a blessing. Money for the memorial was raised by public subscription and it's interesting to note that so much money was donated that

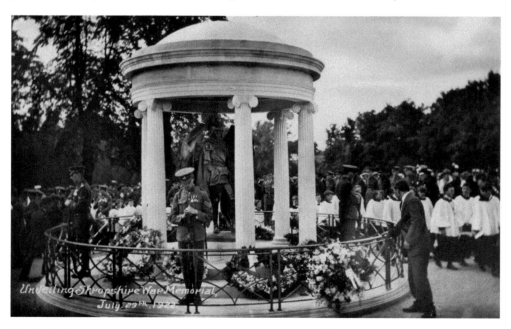

The dedication ceremony in 1922 for the permanent memorial.

there was enough left over to cover the cost of building an extension to the Royal Salop Infirmary. This was opened five years later and consisted of a new wing with twenty-two beds for children and eight maternity beds.

Inevitably, a little over twenty years later the memorial was rededicated to remember the fallen from another war.

The First and Second World Wars are not the only wars remembered with memorials in this part of town. Standing beside the road above the Quarry, there is an earlier memorial dedicated to the soldiers of the Kings Shropshire Light Infantry, who fought in southern Africa in the Boer War. This memorial features a soldier dressed in the uniform of the time with his head bowed and holding a reversed rifle., When you read the inscription note what a large proportion of these men died not in battle but from disease.

Webb, Mary

In the grounds in front of the Shrewsbury's library there is a bust of a lady who is almost unknown beyond Shropshire, and even during her lifetime she never had the renown she deserved.

Mary Webb was born in 1881 in the village of Leighton near Buildwas and grew up to have a great love of the countryside, which was to strongly influence her writing. At first she wrote mainly poetry, but it is largely for her novels that she is remembered now, and it is in these works that her love of the Shropshire countryside is so strongly evident.

Sadly, she suffered from thyroid problems all her adult life and the disfigurement this caused was probably behind her understanding of her main character in her finest novel, who suffered from a harelip. That novel, *Precious Bane*, was published in

Bust of Mary Webb in the garden beside Shrewsbury Library.

1926 and so impressed the prime minister, Stanley Baldwin, that he wrote a foreword for the book. But she was never able to enjoy the success that his acclaim brought her as she died soon afterwards in 1928.

Wesley House

The plaque beside the door tells us that John Wesley preached here in 1761 on his first visit to Shrewsbury. John Wesley was born in 1703 and, along with his brother Charles, was one of the founders of the Methodist movement within the church. He was a man who travelled widely around the country, preaching his form of studying the Christian faith methodically – hence the term Methodist, which, it must be admitted, was for a long time a term of derision by many people.

Apparently it was he who coined the term 'agree to disagree' when he used it in a memorial service for another churchman with whom he had many a theological 'discussion'. I cannot help but rather like a man who is also known for writing one of my favourite carols, 'Hark! The Herald Angels Sing'.

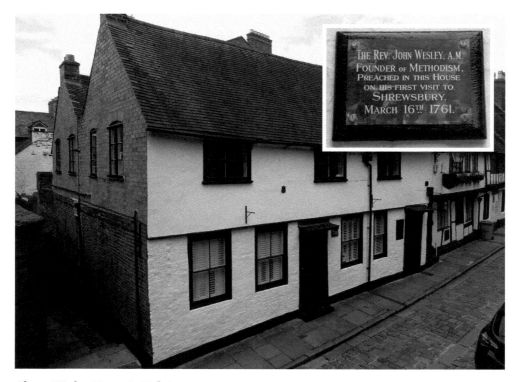

Above: Wesley House in Fish Street.

Inset: The plaque by the door.

Xmas Carol (or should it be *A Christmas Carol*?)

It's a wonder that Shrewsbury, with its beautiful old buildings, enticing little streets and local people only too happy to act as extras, hasn't been turned into a permanent film set; it's ready-made for any film set within the last few hundred years. One film, however, has come to be so closely associated with the town that each Christmas tours are available for lovers of Charles Dickens's book, *A Christmas Carol*.

There have been numerous film versions over the years. The Shrewsbury one was filmed in 1984 and starred George C. Scott as Ebenezer Scrooge. So many different

Scrooge's grave in New St Chad's churchyard.

parts of the town featured in the film – from the Square, with its snowy market scenes, to the former Judge's Lodging in Belmont, the façade of which served as Scrooge's house. Tiny Tim's house, on the other hand, was in Bear Steps (with, somehow, a backdrop that showed St Paul's Cathedral in London), while those Christmas parties that took place in Fezziwig's house were filmed in the interior of Tanner's wine shop in Wyle Cop. The scene in the story in which Scrooge visits his own grave was filmed in the churchyard of New St Chad's Church. The grave is still there and attracts many visitors.

Little did Charles Dickens know when he wrote his novel just what a success it would still be more than 150 years later. Dickens travelled all over the place, both collecting ideas for his books and also giving readings. He came to Shrewsbury in 1858 and stayed at the Lion Hotel in Wyle Cop. While there he wrote a letter to his daughter in which he described the view from his bedroom window, saying that he could 'look all down the street [at Wyle Cop] at the strangest black and white houses, all of many shapes except straight shapes'.

Perhaps it was as a result of this visit that he decided that Sydney Carton, his main character in *A Tale of Two Cities*, which was published the following year, should be described as having been an old boy of Shrewsbury School.

Y

York, Dukes of

The title of Duke of York is usually given to a monarch's second son and, as a title, has no real association with Shrewsbury. Despite this we have links to two such dukes, although there is argument as to just which duke is the first of them.

This first Duke of York stands proudly between the main windows on the old market hall. The statue originally stood on the medieval Welsh Bridge (once known as St George's Bridge) and was moved to its present site when that bridge was dismantled in the 1790s. So, who is he? There are any number of dukes of York he

Duke of York statue on the Old Market Hall.

may represent, but most likely he's the Duke of York who lived in the mid-1400s and governed England for a time during the madness of Henry VI.

The other Duke of York was slightly later. He was born in 1473 in the Blackfriars monastery, which then occupied the site where the Parade Shopping Centre now sits. Richard of Shrewsbury (in those days people of importance were often named for their place of birth) is now well known in history, despite his brief life, for he was one of the Princes in the Tower. He was the second son of Edward IV and went from Shrewsbury to live with his elder brother (another Edward) in Ludlow Castle. It was from Ludlow that the two boys were taken to the Tower of London when their uncle Richard usurped the throne, and they were never to be seen again. Richard was ten years old when he disappeared.

Z

Zade, Professor Martin

Despite their purpose cemeteries can frequently be very comforting places especially when they are well cared for, and the Longden Road Cemetery is one such, having a large group of friends who tend both the grounds and the graves. The cemetery covers an area of 30 acres and was consecrated in 1856.

It's a general cemetery in that it acts as a resting place for people of all faiths and nations, and this is brought very much to the mind when one sees the war graves there, with graves not just for British soldiers but also other nationalities including the graves of prisoners of war who died before they could be repatriated. I always find it especially moving when I see the large number of such First World War graves with deaths dated to 1919 – for many the Spanish Flu epidemic did what war couldn't.

As you wander around such places you never know what you will find. There may be famous local people, for example. One lady buried here is the writer Mary Webb. Another is Julia Wightman, who was the wife of a vicar of St Alkmund's and, as part of her fight against alcoholism, established a working men's club in town where men could not only read and socialise generally but also self-improve through evening classes – anything to free them from the temptation of drink. Another famous local is the architect Samuel Pountney Smith, who not only designed the chapel of rest but also a number of other buildings locally. It was he who restored the church at Battlefield, for example. Then there are ordinary people who did unusual things, such as the taxidermist. Indeed, you never know what – or who – you will find.

One unexpected grave is that of Professor Martin Zade. He was Jewish and born in Germany in 1877. In 1930s Nazi Germany he was working as a professor of ophthalmology at Heidelberg University and realised he needed to escape from persecution, which he did in 1939. He finally came to Shrewsbury where he worked at the Eye, Ear and Throat Hospital for a time before he died in 1944. On his grave there is a quote from another German, Goethe, that reads:

> That you have no ending, Makes you Great,
> And that you have no Beginning, That is your Fate.

The Second World War graves.

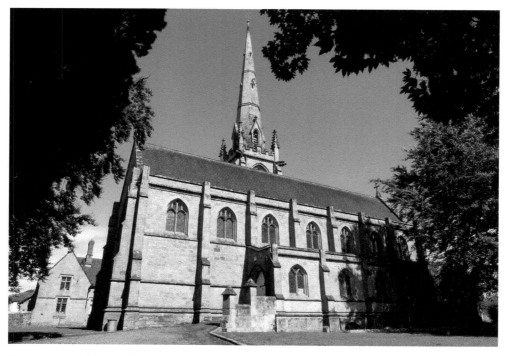

Pountney Smith's chapel of rest.